SAN DIEGO — our home for over 100 years. Thank you for sharing in our history and helping us write our next chapter together.

From your friends at

San Diego

Through the Lens of Aaron Chang

San Diego is a place of natural beauty and modern style, unlike any other city in the world. With a unique Southern California beach lifestyle, this metropolis is comprised of a series of smaller beach communities that collectively make San Diego one of the world's ultimate surf cities.

In the past decade, San Diego's expanding skyline has drawn visitors and relocators in droves. Iconic San Diego spots include Torrey Pines State Park, La Jolla Cove, North County's coastal beach towns, Balboa Park and the newly remodeled luxury waterfront plaza, the Headquarters.

In 2016, Aaron was voted "Best San Diego Artist" and his galleries "Best San Diego Gallery" by Ranch & Coast magazine; A first winning both categories. In 2014 and 2015, Aaron was named San Diego's "Ambassador of the Arts" by the San Diego Tourism Board.

The cover photo is one of Aaron's newest fine art photography releases. This spectacular photograph captures the last rays of sunlight, reflected in the tide pools, at the landmark surfing spot Cardiff Reef. This elegant image plays beautifully with light and shadow while capturing the beauty of a classic San Diego sunset.

Experience the beauty of San Diego coastal living, as seen through the lens of master photographer and award-winning gallery owner, Aaron Chang.

In this interactive book, you will find web links to experience Aaron's stories behind his shots, slideshow videos and photography tips. Simply enter the URL link given in the captions in your browser to see the videos.

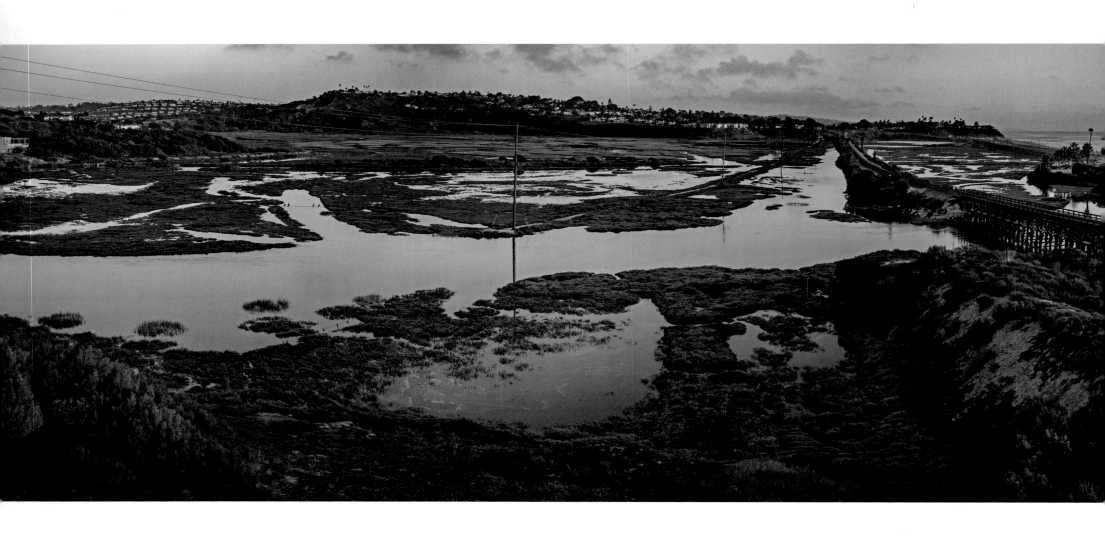

SAN ELIJO EVENING PANORAMIC

A 180 degree view of the San Elijo lagoon captures the beauty of North Coastal living. Shot at sunset, this peaceful panoramic has incredibly high resolution, enabling the viewer to step into a day in the life of Cardiff-by-the-Sea.

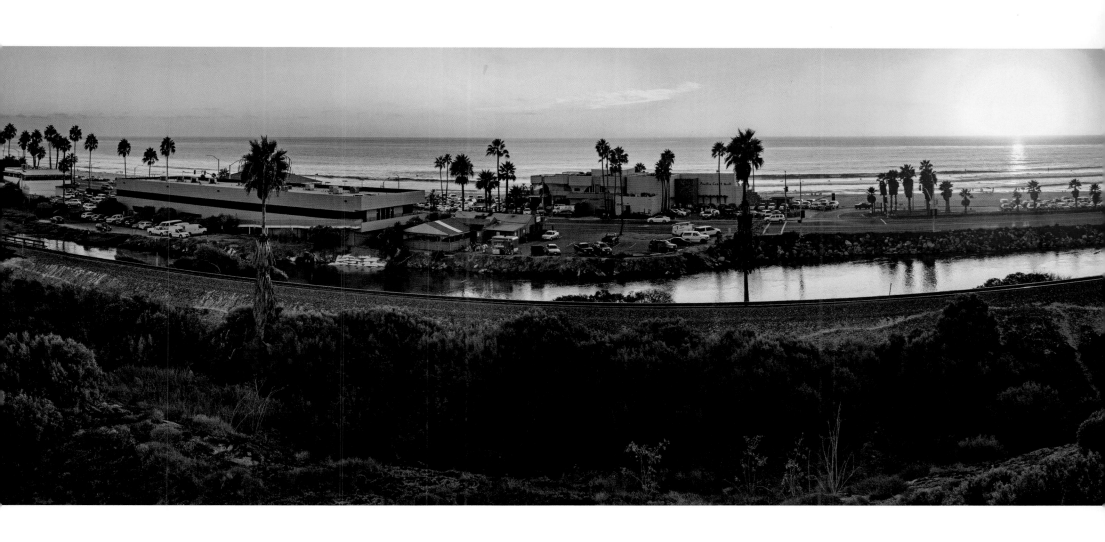

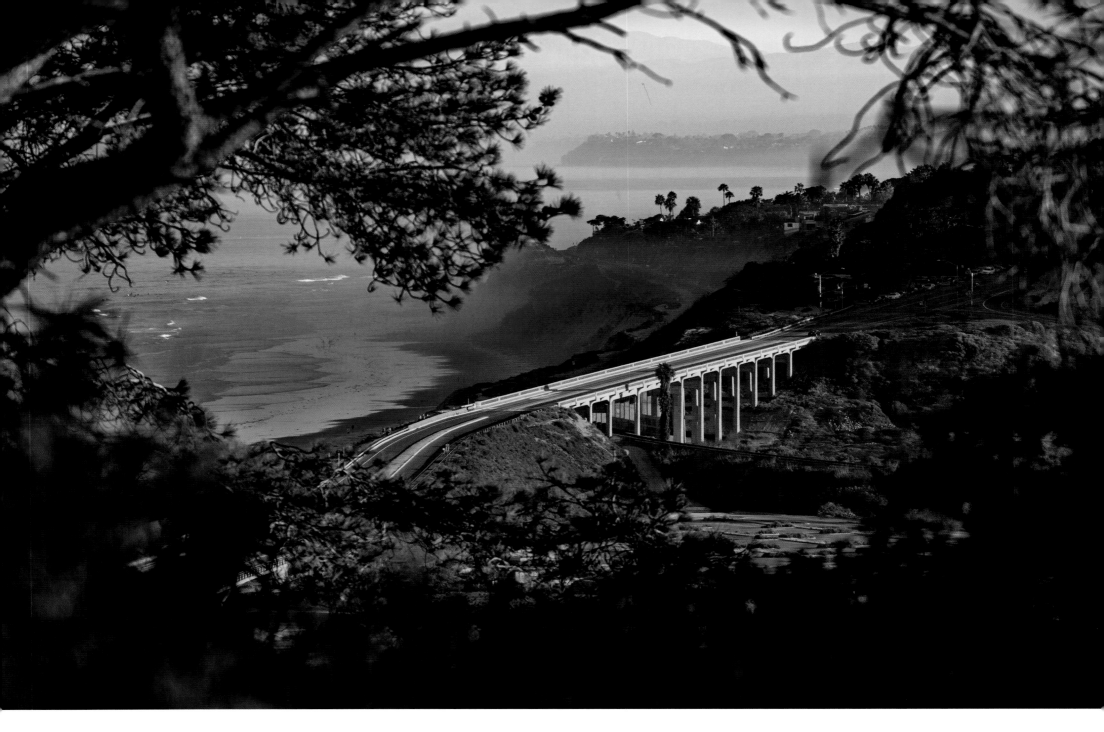

BRIDGE AT TORREY PINES
Misty early morning light illuminates the bridge where the estuary meets the sea. You can see the point at Del Mar and the headlands of Encinitas in the distance. To see Aaron's San Diego surf and ocean photography slideshow: AaronChang.com/san-diego-photography.

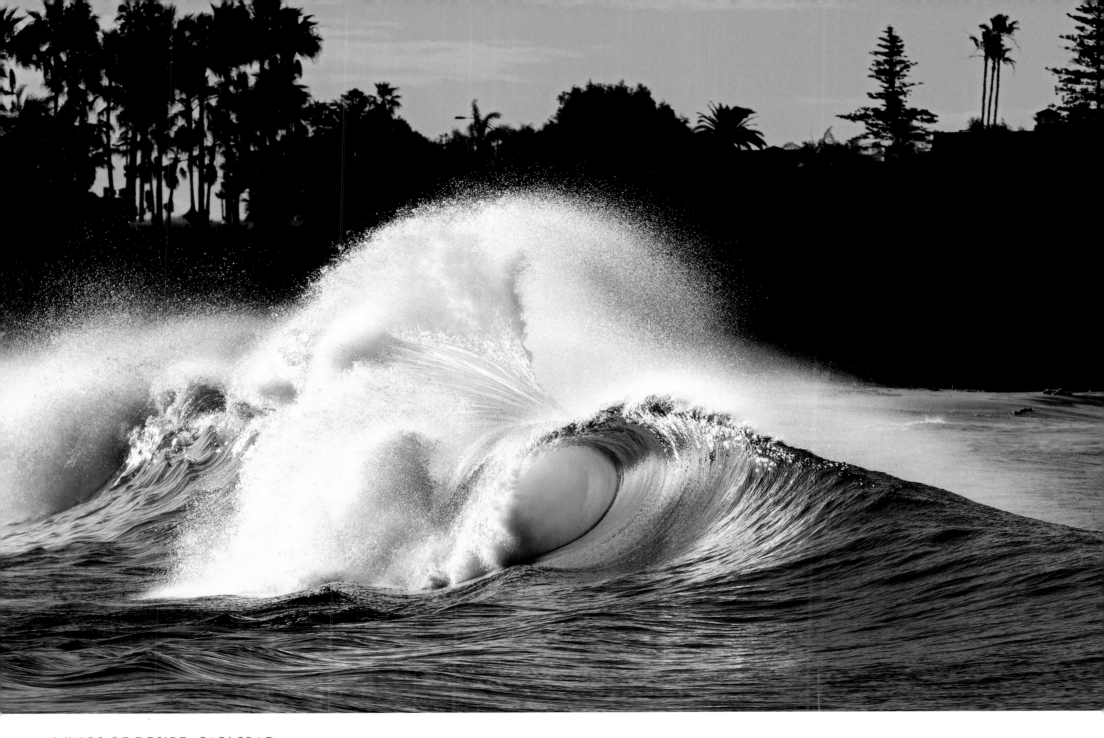

WINGS OF DESIRE, CARLSBAD

On a crisp California morning, the high tide backwash collides with an incoming wave, creating a plume of sparkling water silhouetted against the tropical foliage.

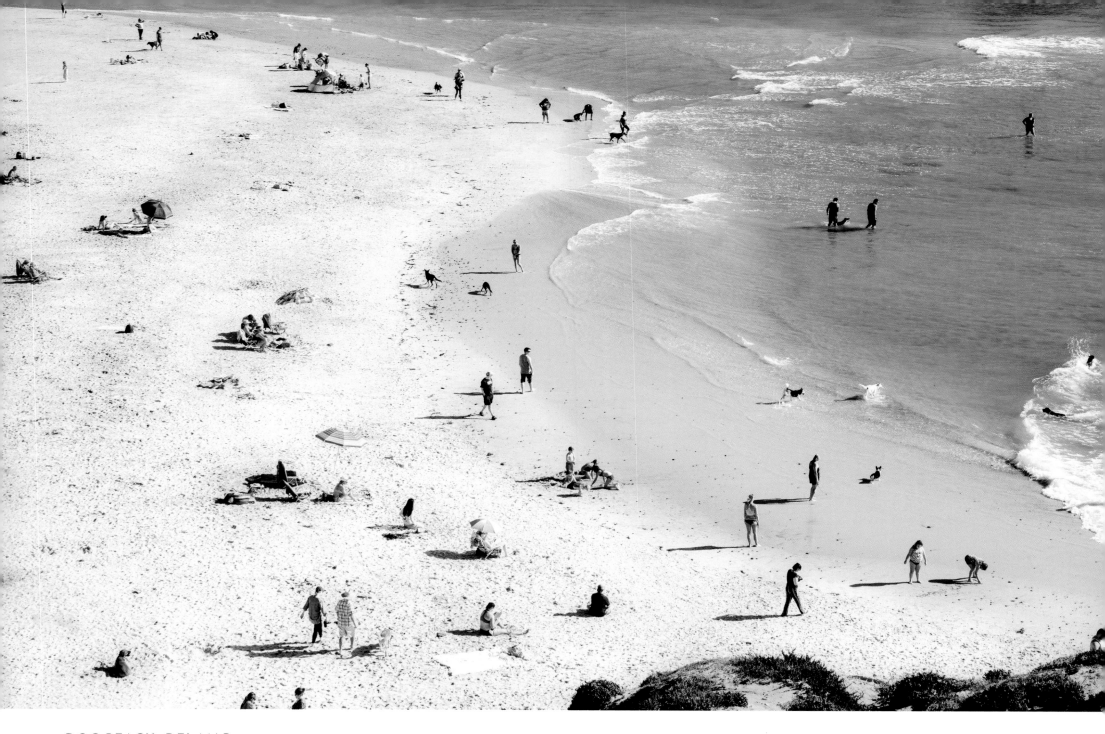

DOG BEACH, DEL MAR
A playful day on the beach in Del Mar where dogs run free, the water is warm and life is good. This beach is home to the Helen Woodward Dog Surfing Competition.

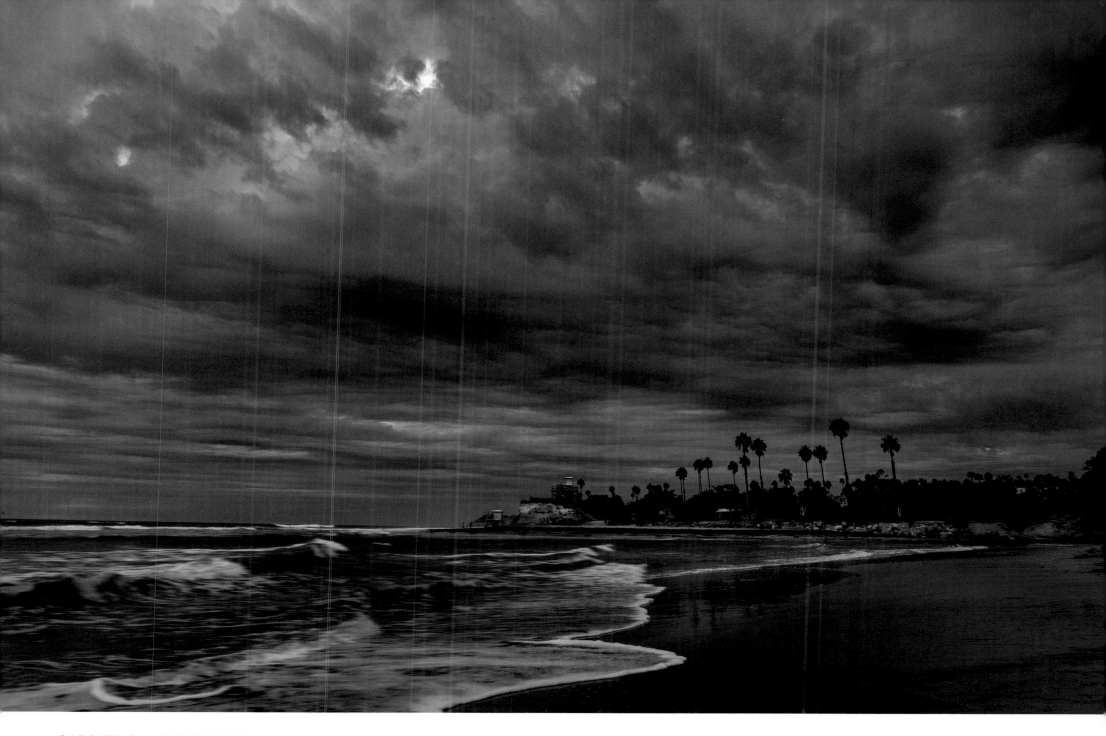

CARDIFF CAMPGROUNDS

A blanket of clouds cloaks the coast in this moody portrait of the beachside campgrounds in North Coastal Cardiff-by-the-Sea.

To see Aaron's video about Cardiff-by-the-Sea: AaronChang.com/Cardif-Royale_blog

BLUE MAGIC

This tonal, abstract wave was photographed in La Jolla on a crystal clear day. Shot from the cliffs above the surf, the shades of blue captured convey the serenity of a gentle summer swell.

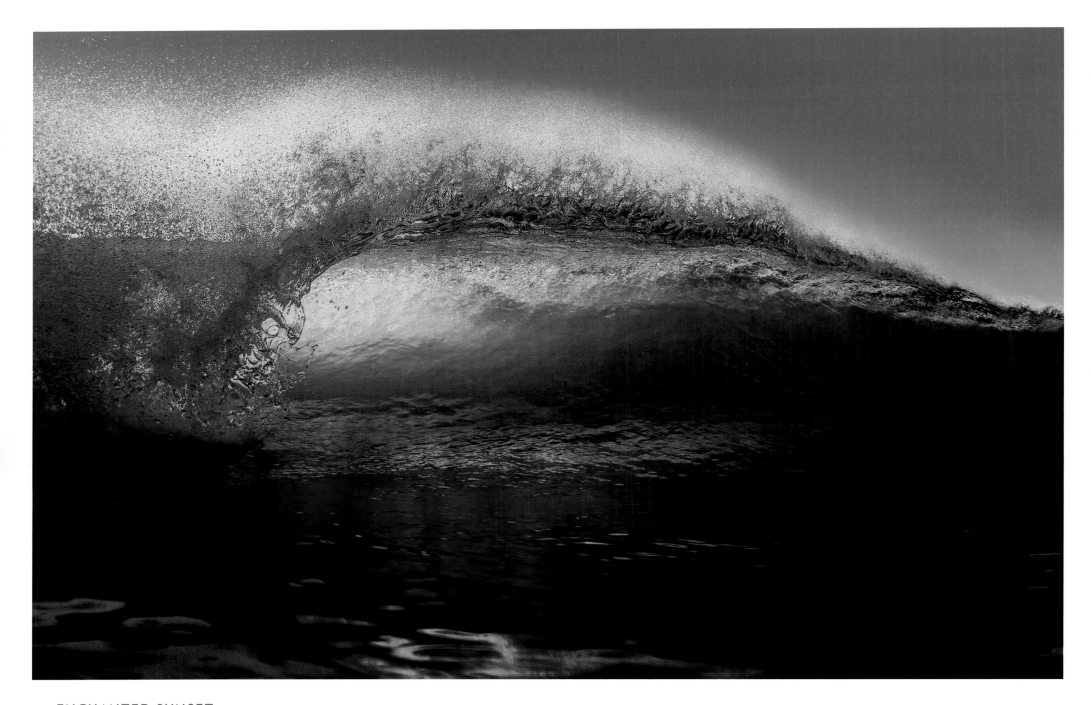

ENCHANTED SUNSET

This extraordinary view was captured from the water during the last moments of a perfect sunset in Solana Beach.
The light offshore wind turns each airborne water drop into a lens, refracting the light of the setting sun.

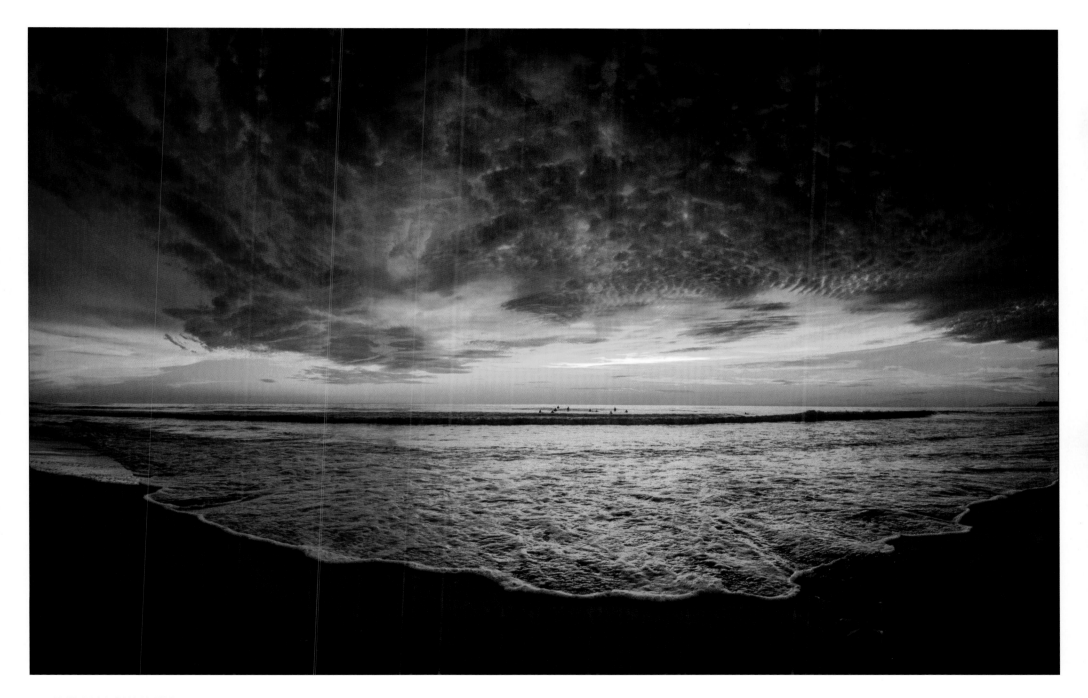

INDIAN SUMMER

Shot on a warm, tropical Indian summer evening at Cardiff Reef. These balmy days are rare, treasured moments in Southern California.

To see Aaron's Endless Summer video and collection: AaronChang.com/endless-summer_blog

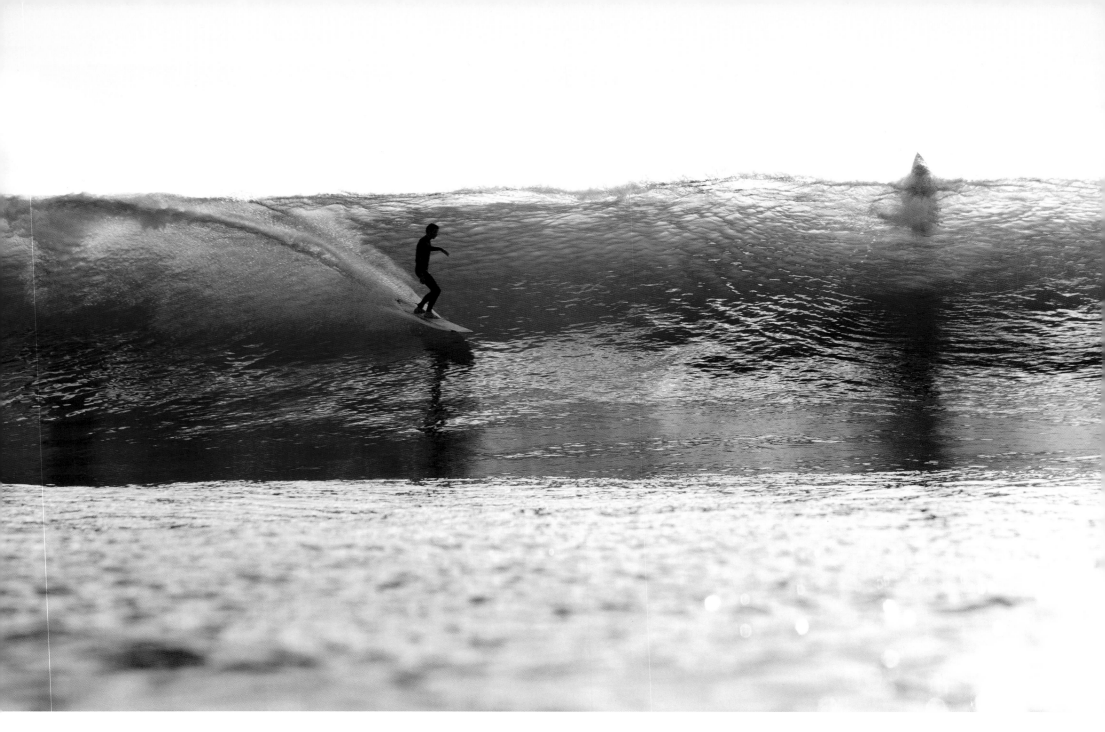

JOEL TUDOR
Longboarding surf legend, Joel Tudor, glides down the face of a wave with style and grace in La Jolla at Black's Beach.

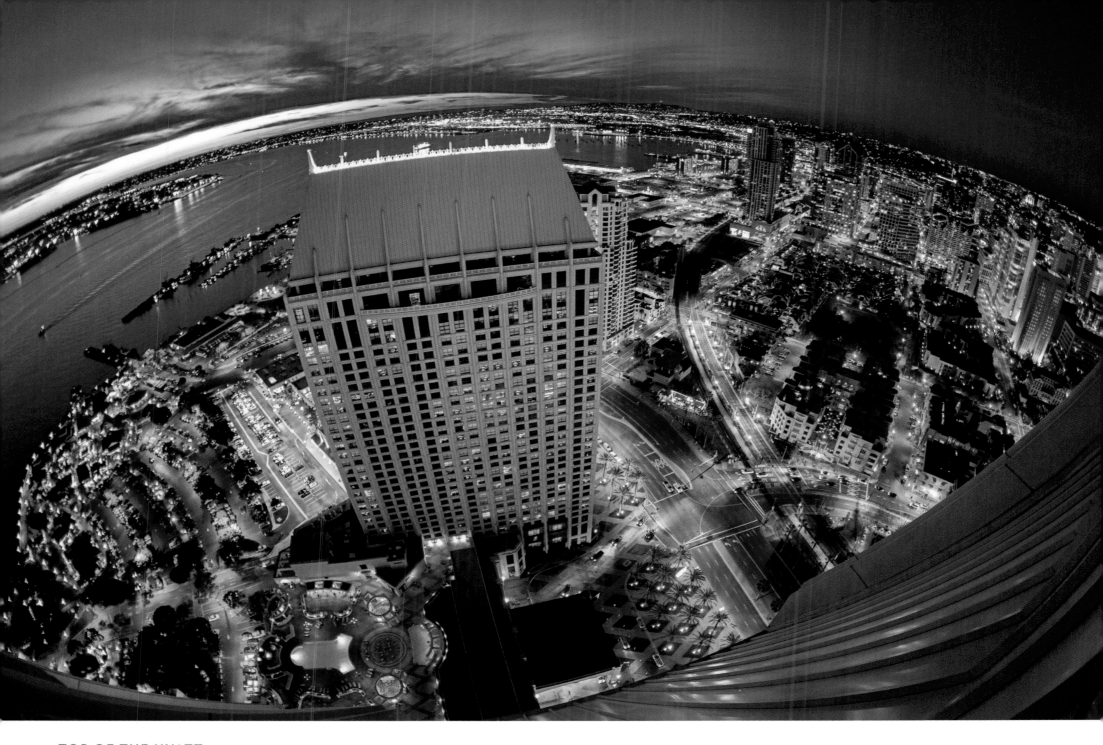

TOP OF THE HYATT

One of the best views of the city by far, this image captures the beauty and city life of San Diego. Not a bad view with a black martini in hand, watching the city come to life after a splendid sunset. For info on Aaron's guided walking photo tour around San Diego bay, go to: AaronChang.com/photo-tour.

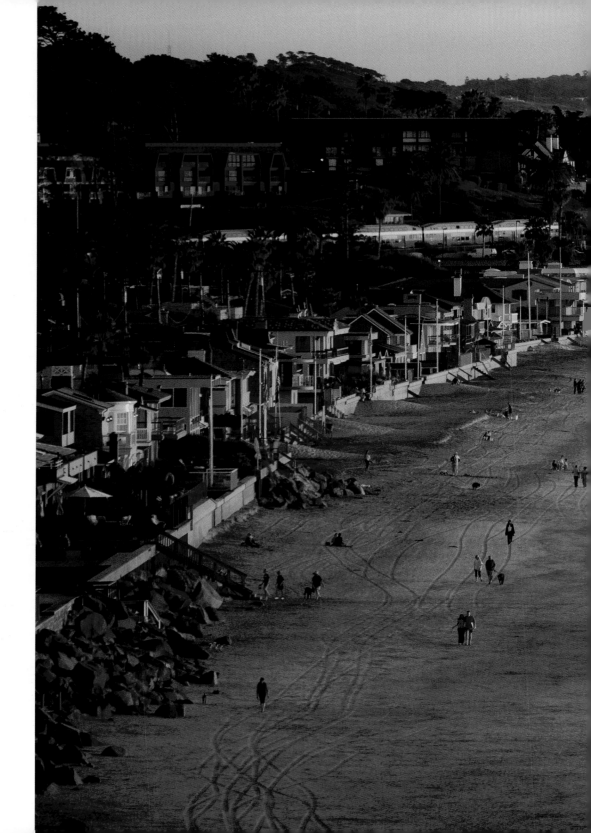

DEL MAR BEACH

This view of Del Mar, shot from the cliffs in Solana Beach, captures the joy of a "Santa Ana" evening where warm winds draw out the community for a stroll on the beach. Open and inviting, this image embodies the beauty of coastal living in Southern California.

To hear Aaron's story about this image, visit AaronChang.com/del-mar-beach.

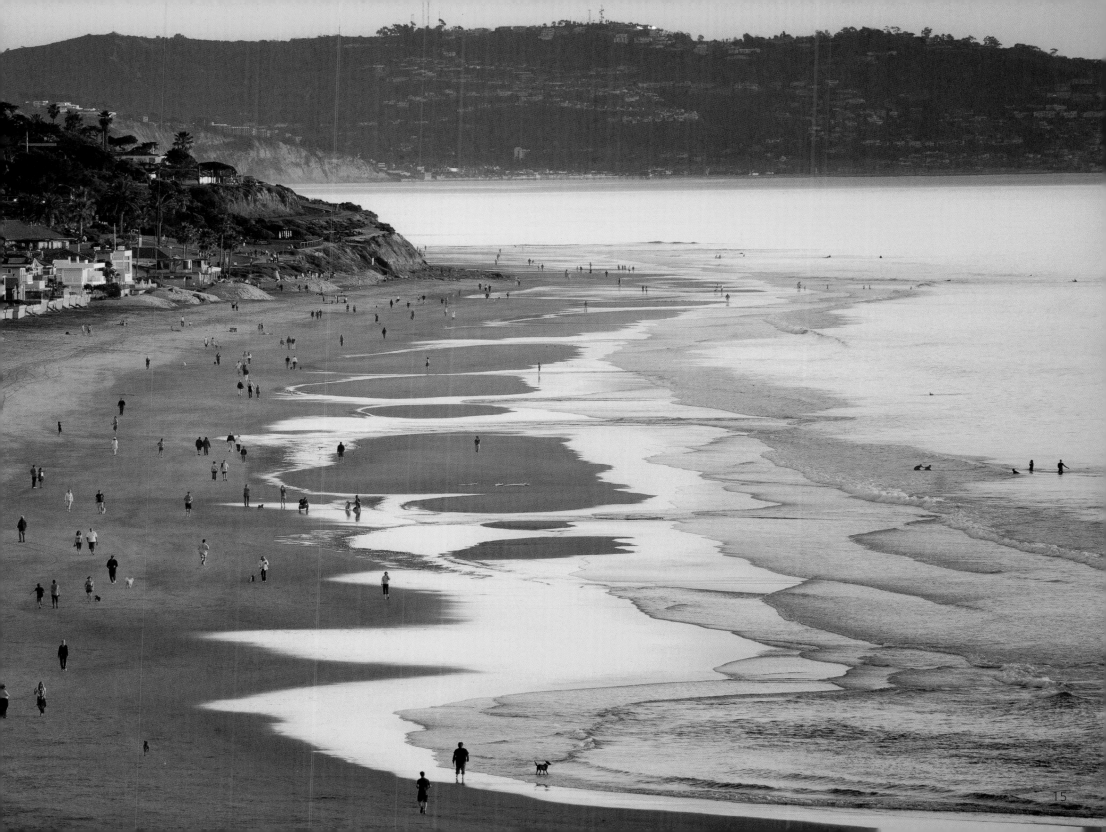

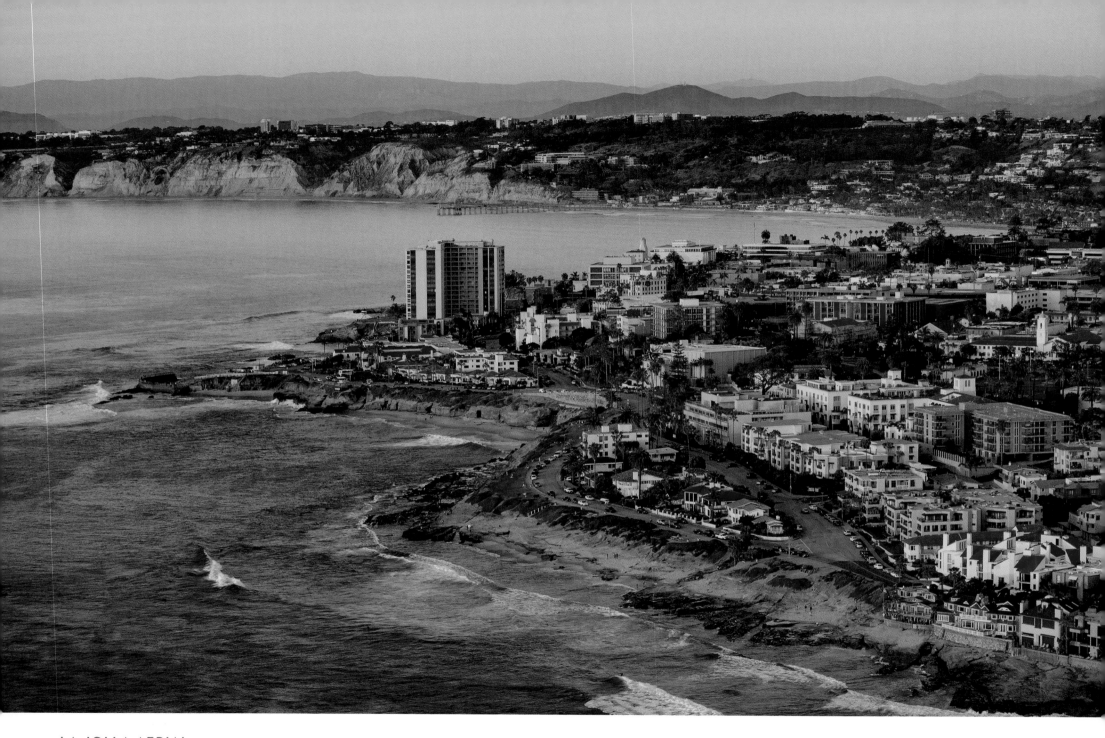

LA JOLLA AERIAL

The jewel of San Diego, downtown La Jolla sits on the coastal point overlooking the majestic cliffs to the north of Black's Beach. In the distance is Scripps Pier, home to the world-famous Scripps Institution of Oceanography.

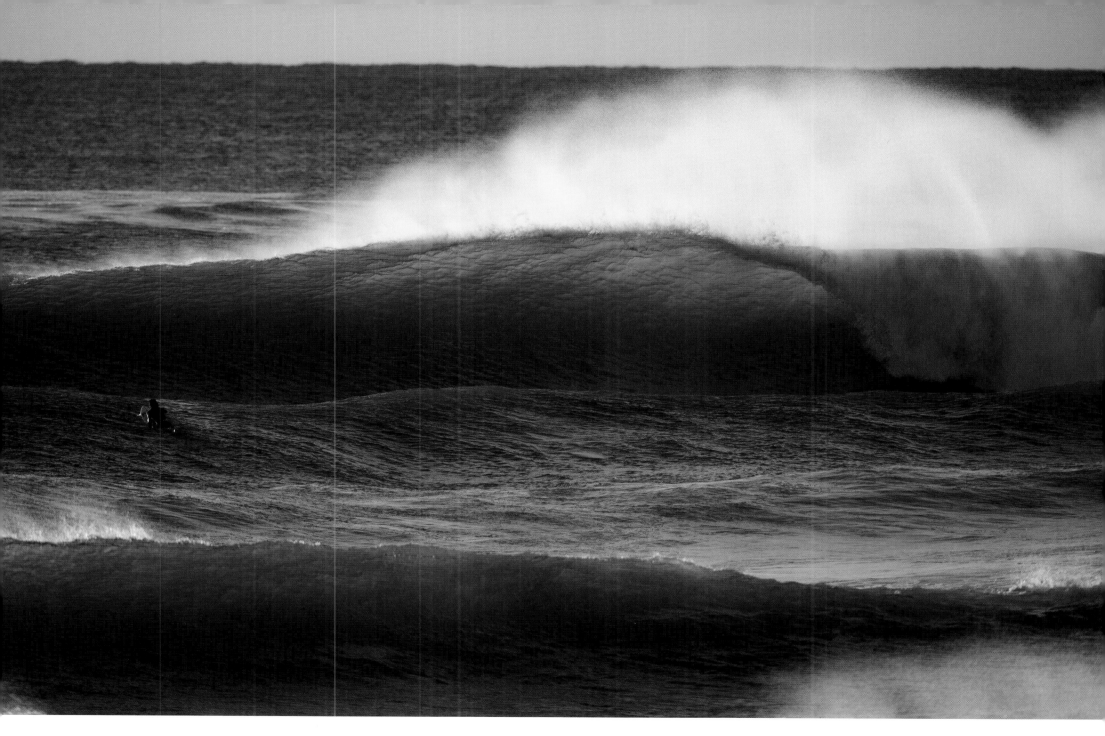

EPIC CARDIFF REEF

A powerful north swell connects with this Cardiff surf break on a crisp California winter day.
Delighted to have the peak to himself, this surfer paddles out to catch his next wave.

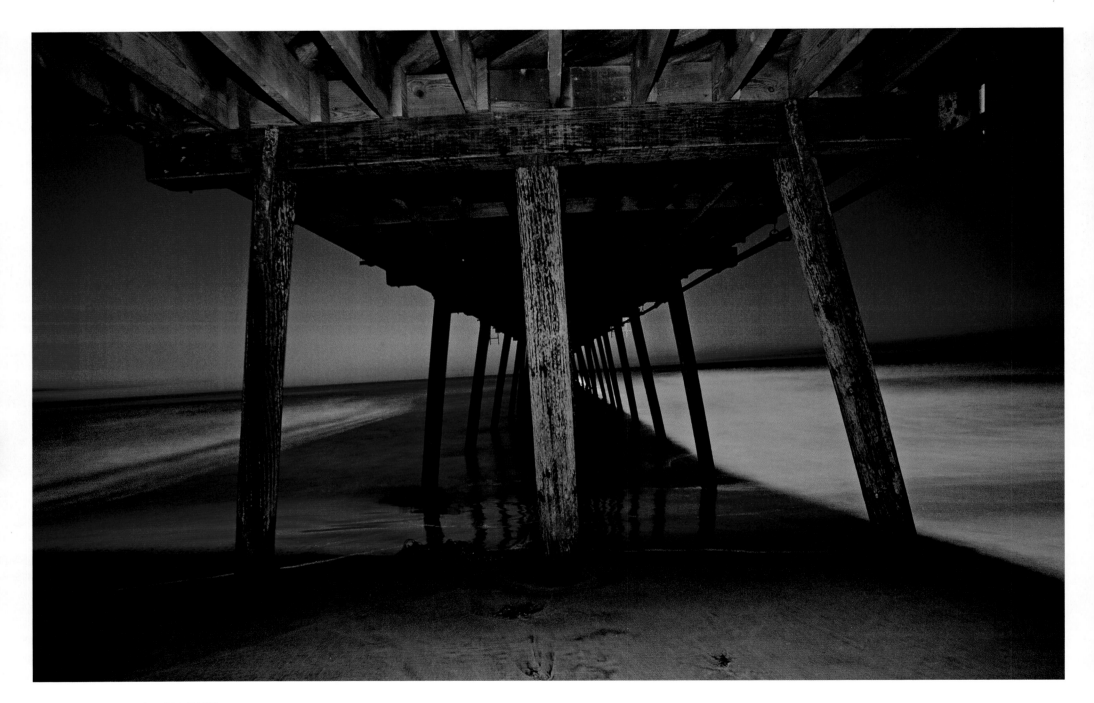

IMPERIAL BEACH PIER

In this photo, sodium vapor lights, from a bygone era, cast a turquoise hue on the water while contrasting with a fiery red sunset.

To see Aaron's video behind this iconic shot of IB Pier: AaronChang.com/ibpier

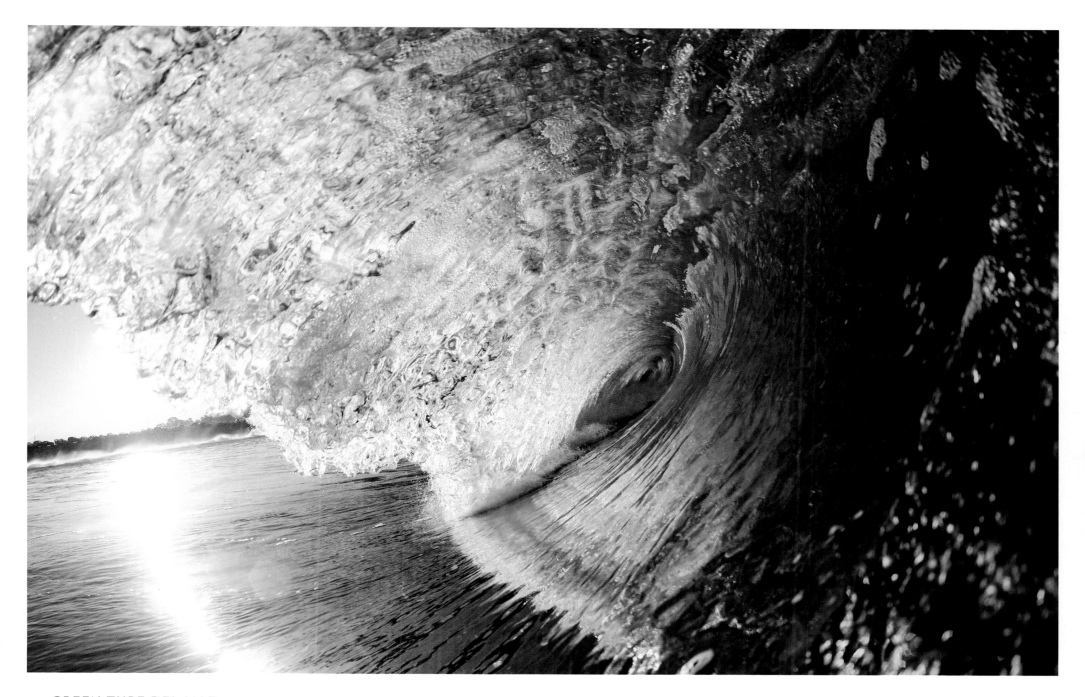

GREEN TUBE DEL MAR

A green wave crashes off the shore of Torrey Pines Beach in the first morning light. The Torrey Pines Reserve is in the background.

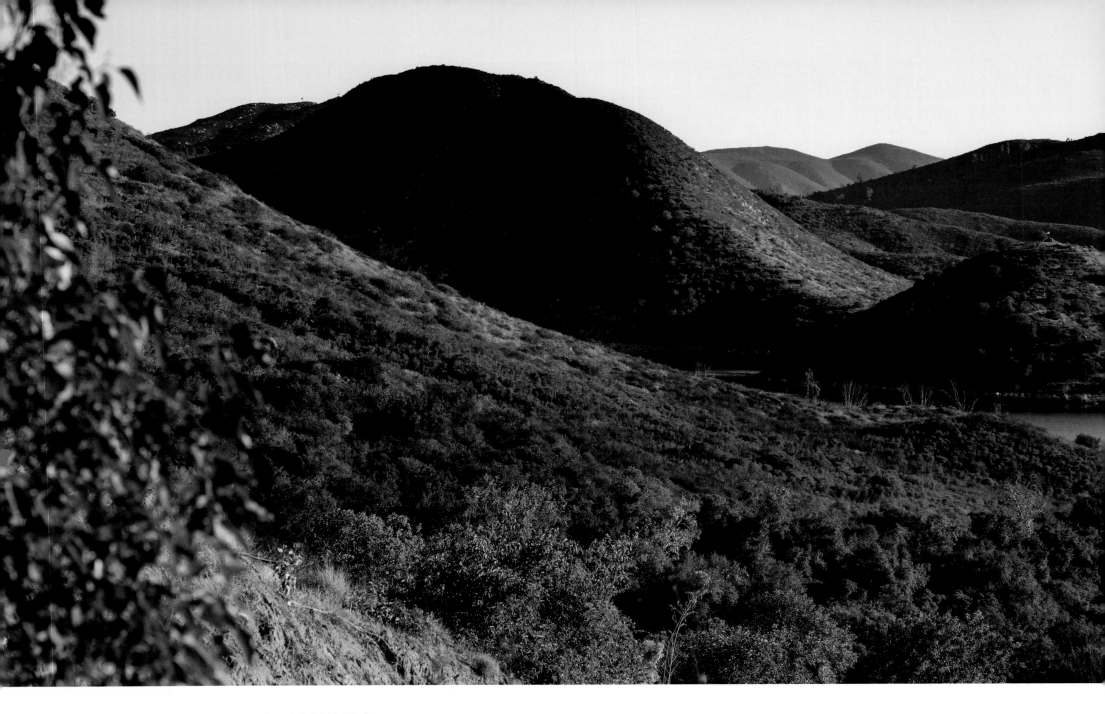

LAKE HODGES PANORAMIC, ESCONDIDO
From a hill above the lake, this southern view reveals the natural beauty of the North County wilds.
To see Aaron's San Diego Inland Collection, commissioned by Sharp Hospital Rancho Bernardo: AaronChang.com/san-diego-inland

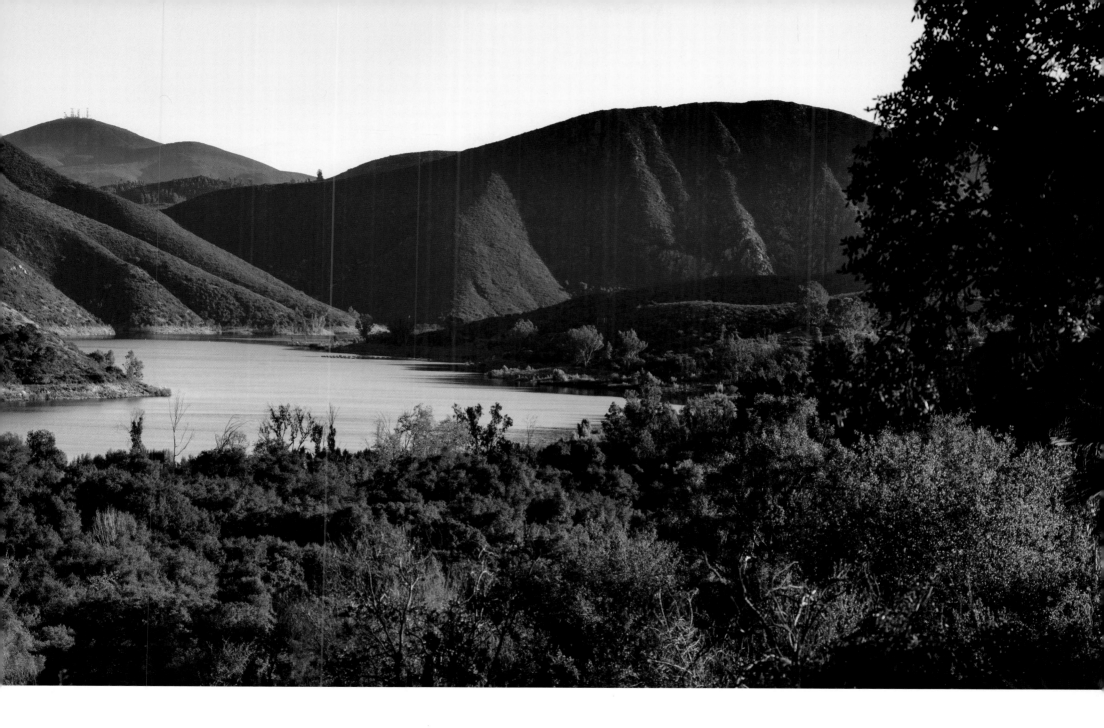

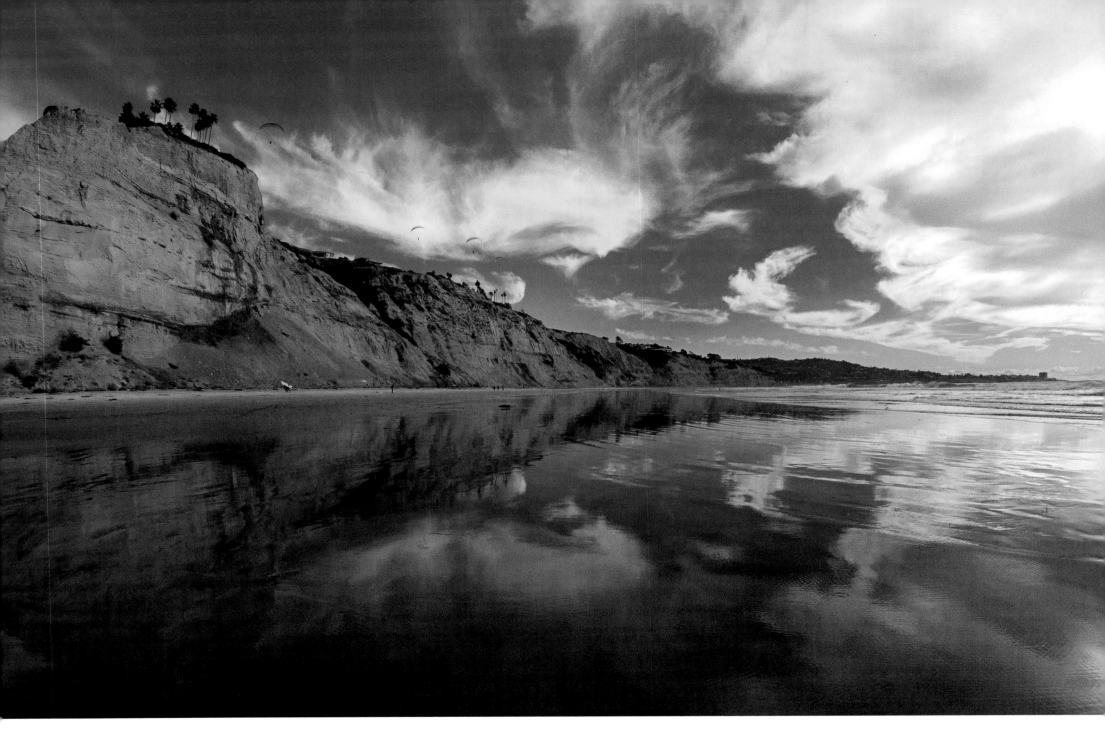

BLACK'S CLIFFS
The low tide creates a mirror effect of the famous La Jolla cliffs at Black's Beach, which is one of the premier surfing breaks in California.

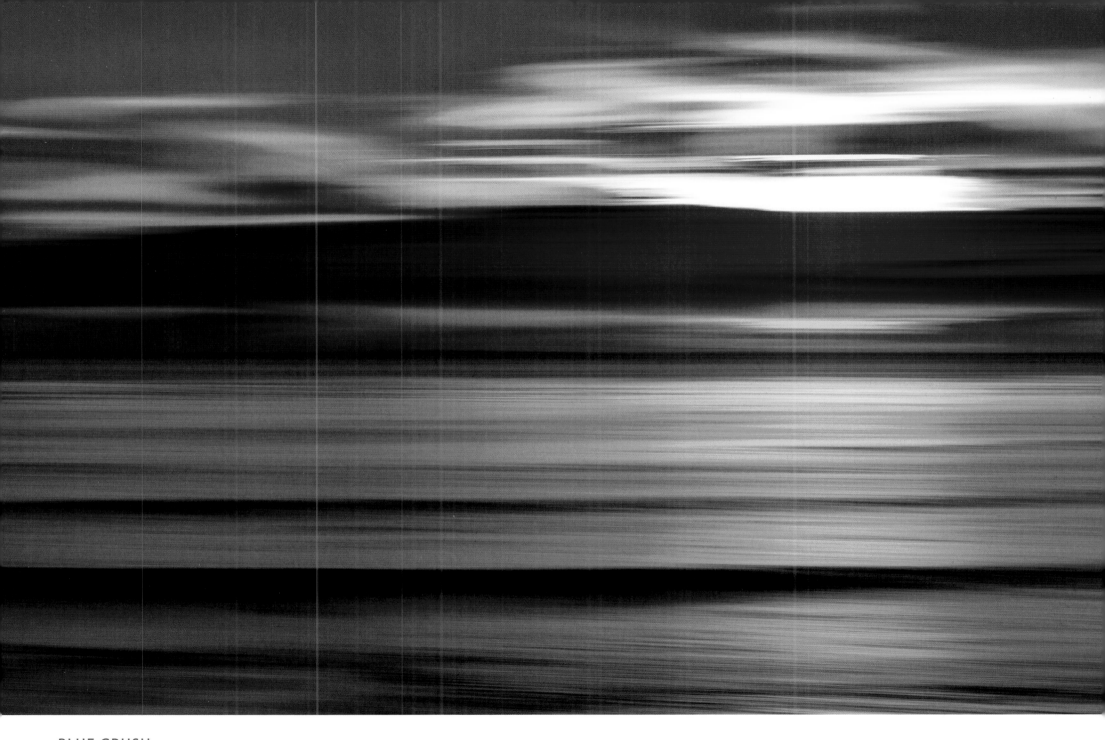

BLUE CRUSH

This collision of a fiery sunset into the steel gray sea contrasts with a serene blue sky. Powerful and uplifting, this inspirational image is one of Aaron's abstract masterpieces.

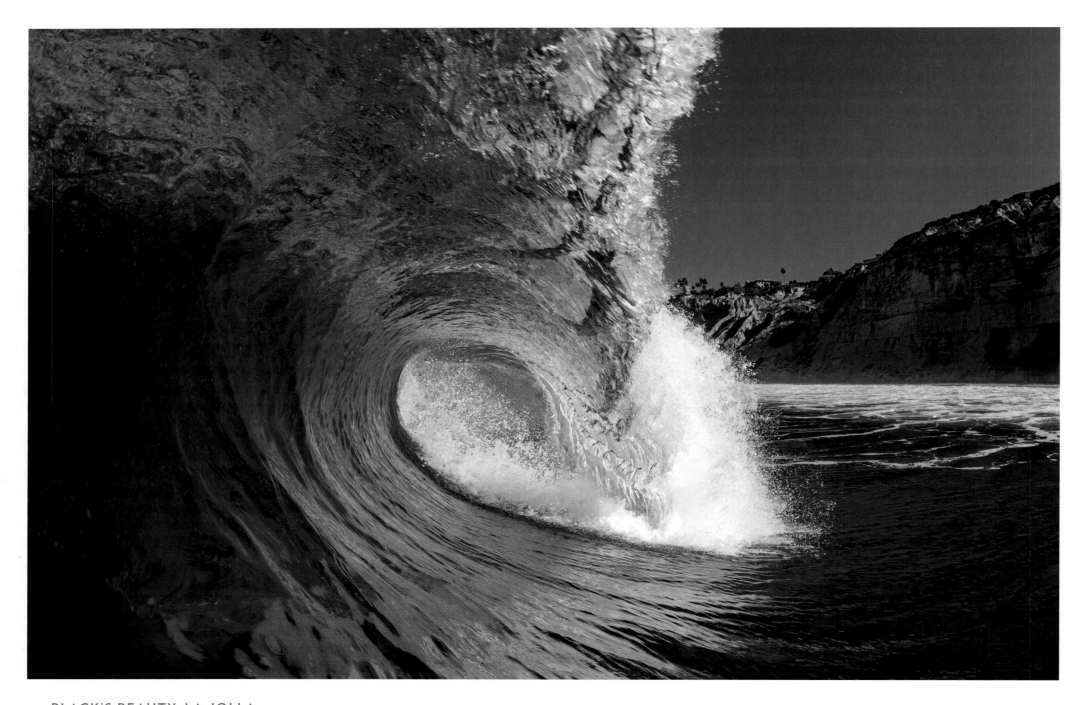

BLACK'S BEAUTY, LA JOLLA

La Jolla consistently has the prettiest water in San Diego and Black's Beach consistently has the best surf. In this photo, the water clarity makes itself visible in the richness of blues and depth of color. All framed by a perfect wave.

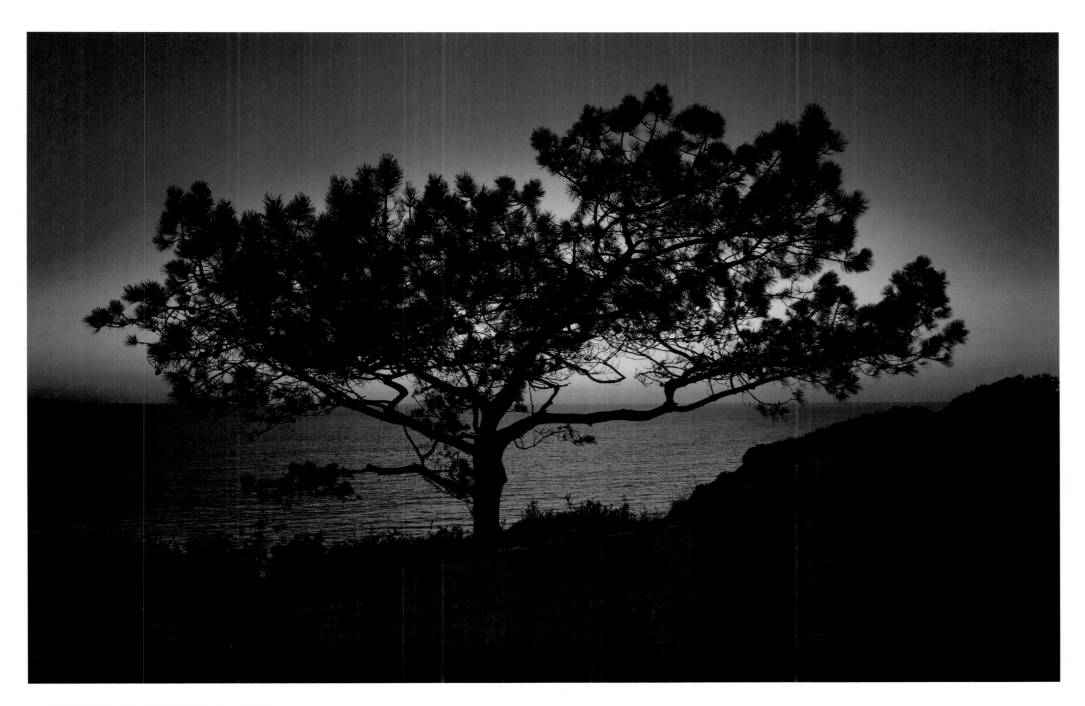

TORREY PINE TREE, LA JOLLA

Perched on the very edge of the cliffs in La Jolla, a rare Torrey pine tree, iconic in its outline, is a lone witness to the setting sun.

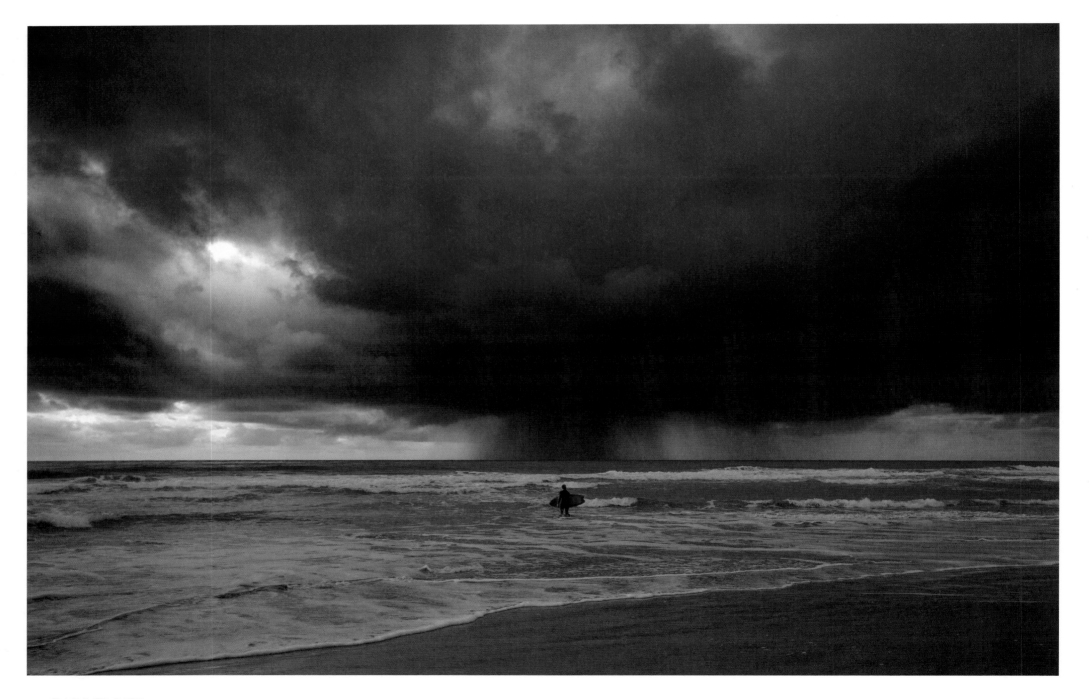

RAIN CLOUD

Learning to surf in the rain takes dedication and courage. Aaron captures this intimate moment in Encinitas.
To see Aaron's video behind Rain Cloud: AaronChang.com/determination

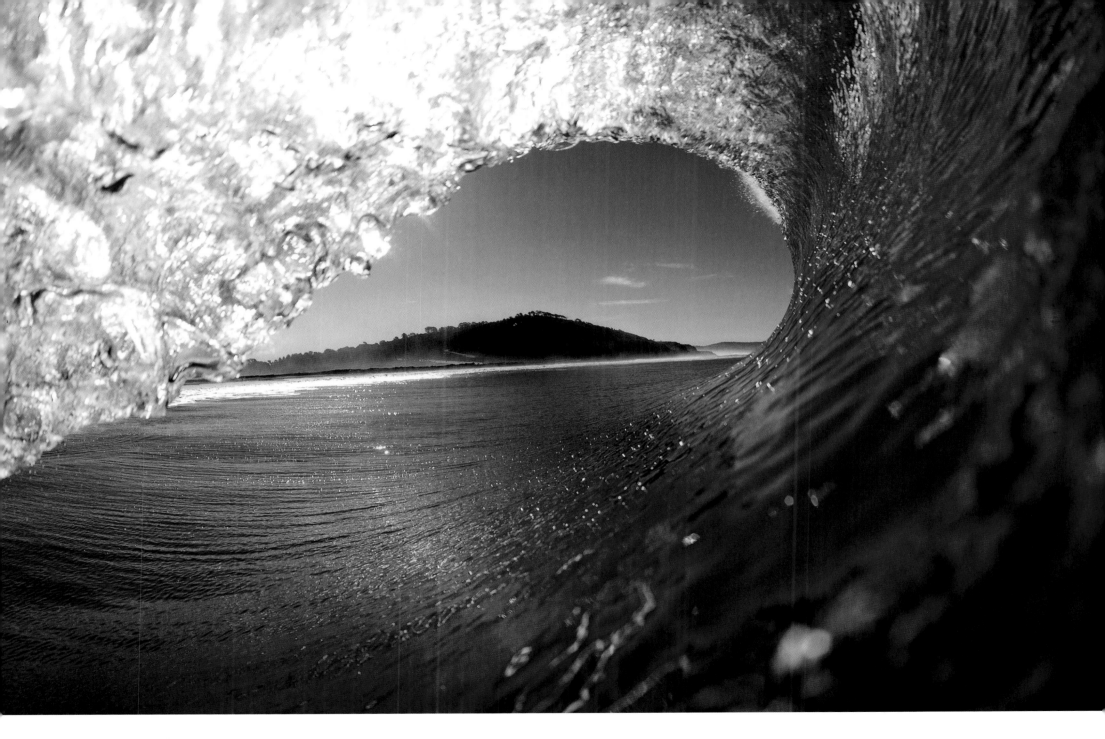

PERFECT VIEW

The pristine beauty of the Pacific Ocean and the Torrey Pines State Reserve is captured by Aaron's lens while he swims inside a wave. A surfer through and through, Aaron's skill at knowing where a wave breaks has helped him capture photos like this one. To see how Aaron captured this best selling gallery shot: AaronChang.com/perfect-view-2

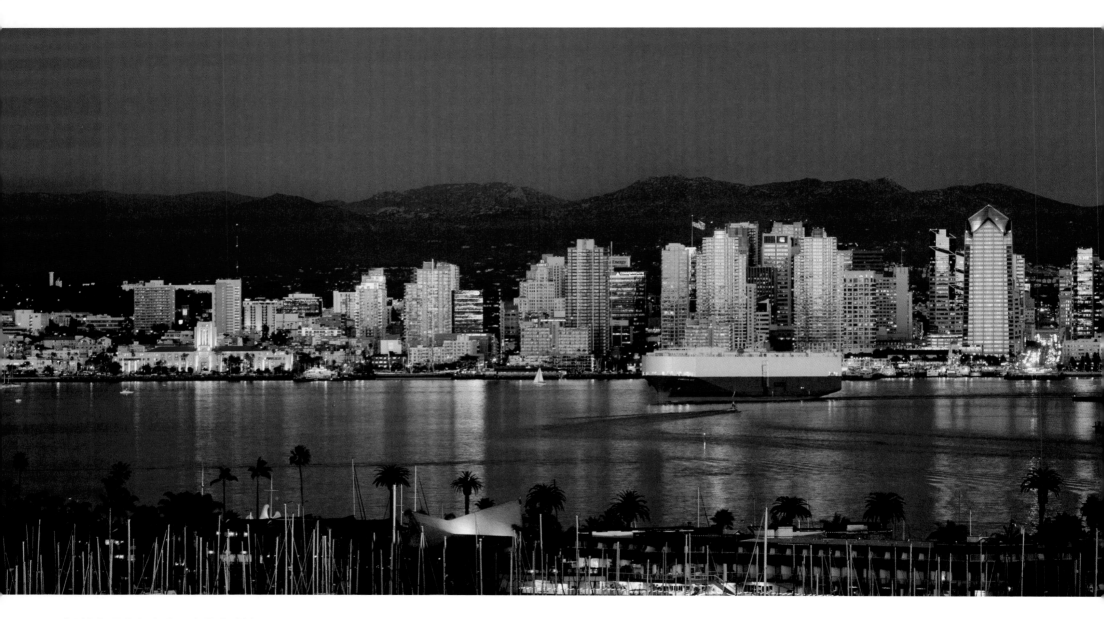

SAN DIEGO SKYLINE DUSK

San Diego lights up in this panoramic cityscape, shot during a golden sunset. Mountains loom over the skyline on a crystal clear "Santa Ana" day. The buzz of commerce and city life comes alive in the details of the image, yet is settled by the elegant surroundings of the water and the afterglow of the setting sun.

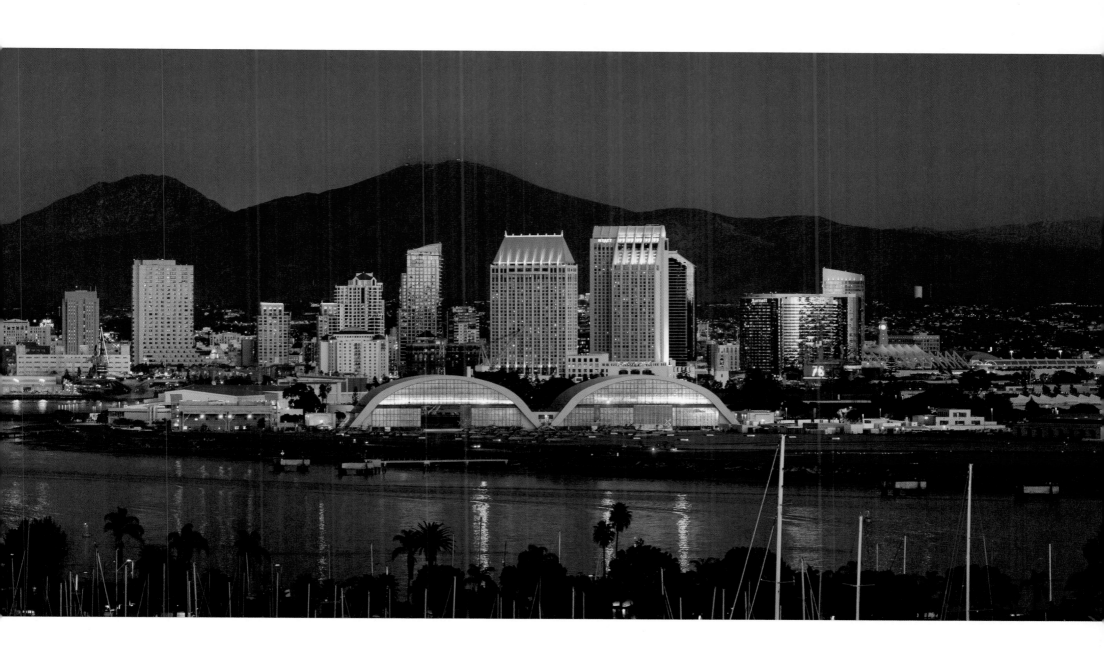

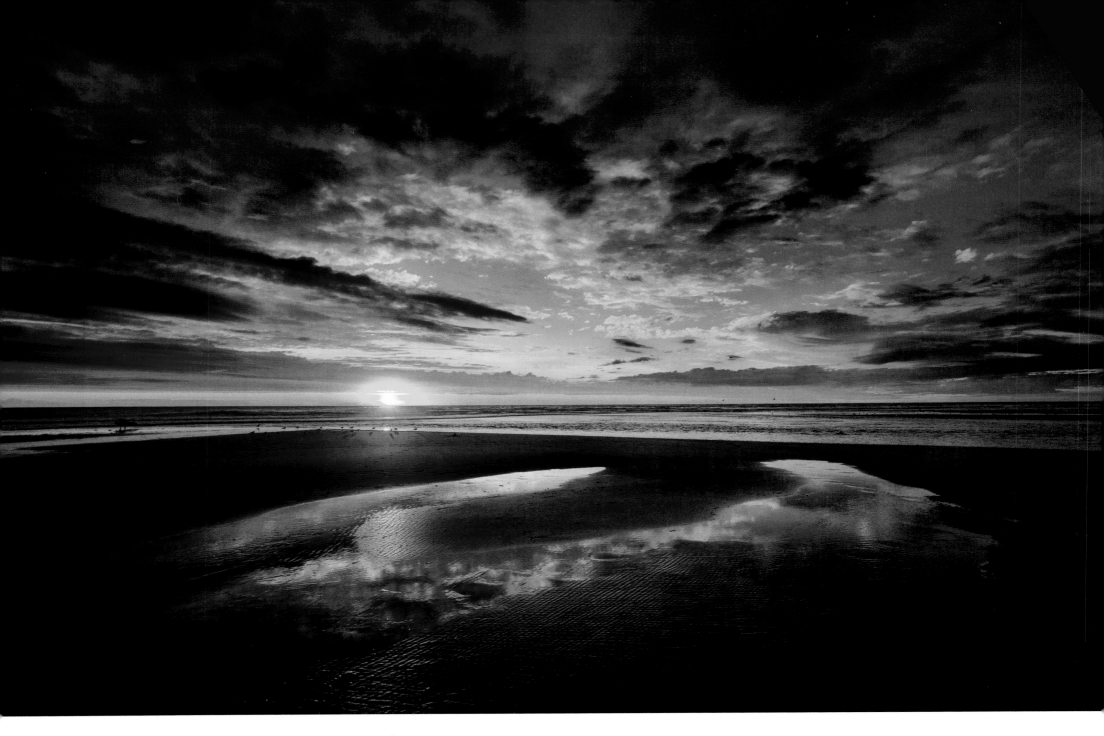

CARDIFF REEF SUNSET (SHOWN ON COVER)

Twice a month, the extreme low tides create a delta where the San Elijo Lagoon empties into the Pacific. Using the pools as reflectors, this dynamic sunset is amplified into a symphony.

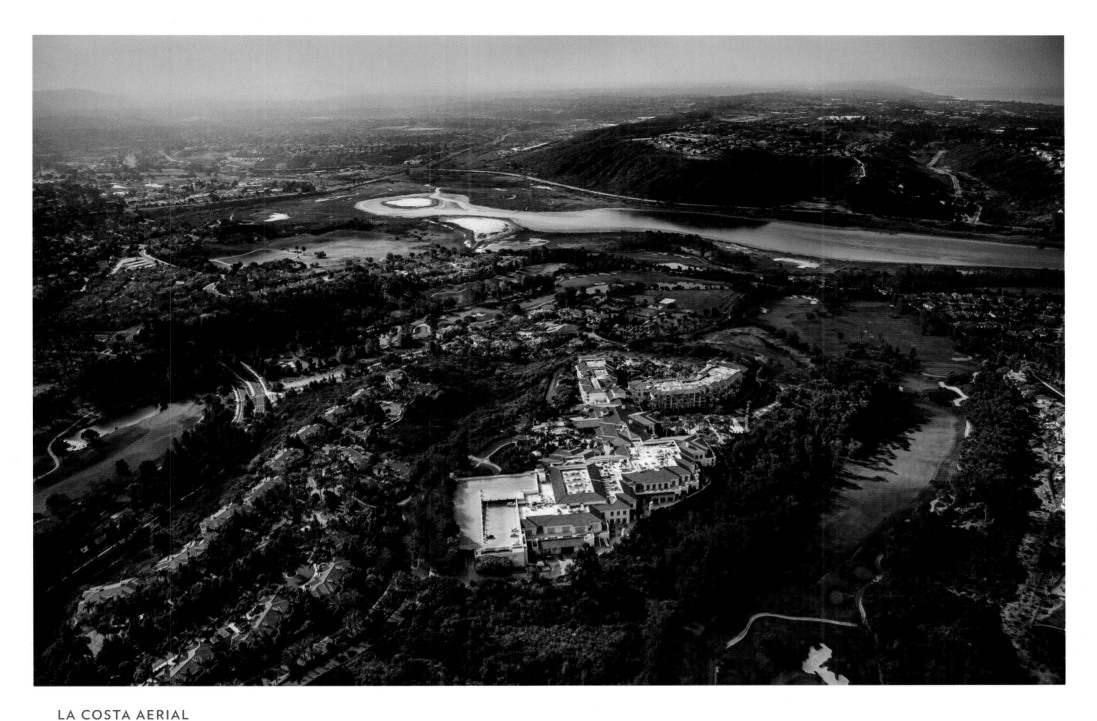

LA COSTA AERIAL
A sweeping view of scenic Carlsbad in North County San Diego features the Park Hyatt Aviara Resort.

To see the Forbes article on Aaron's Coastal Photo Safari in La Costa: AaronChang.com/forbes

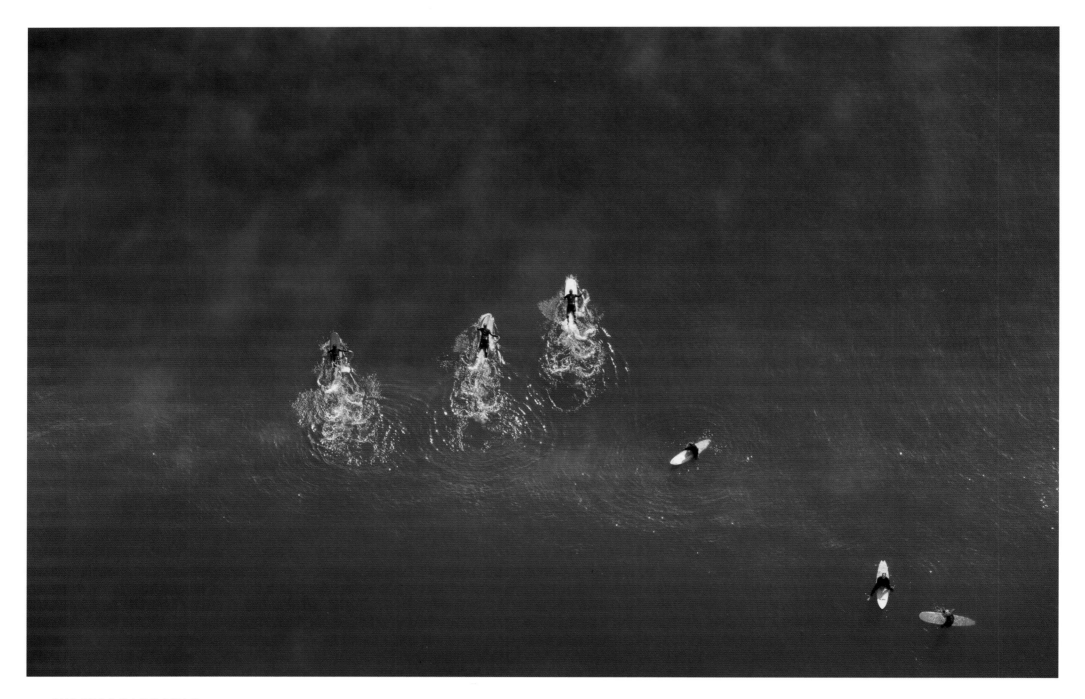

SURFERS PADDLING
Surfers stroke toward shore to catch an incoming set wave in Encinitas.

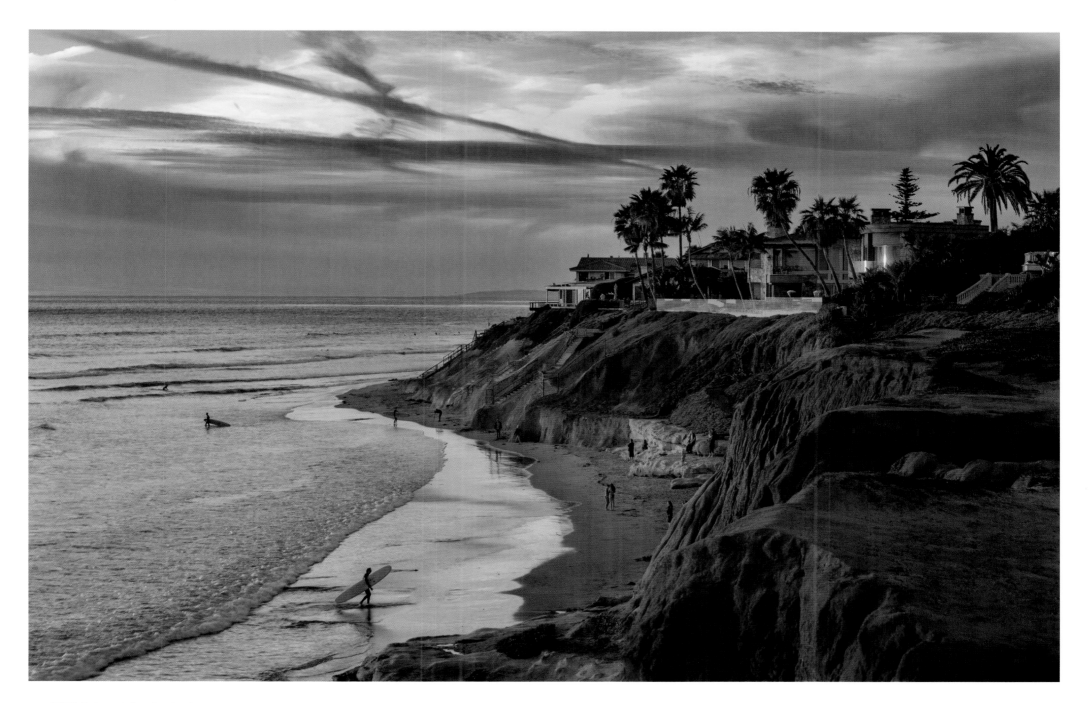

TERRA MAR, CARLSBAD
A Carlsbad landmark, the point at Terra Mar is an iconic California scene at sunset.

SOLANA CLIFFS

Sandstone cliffs are lit up by the setting sun as people walk and surf, enjoying the beauty of Solana Beach. Carlsbad can be seen in the distance.

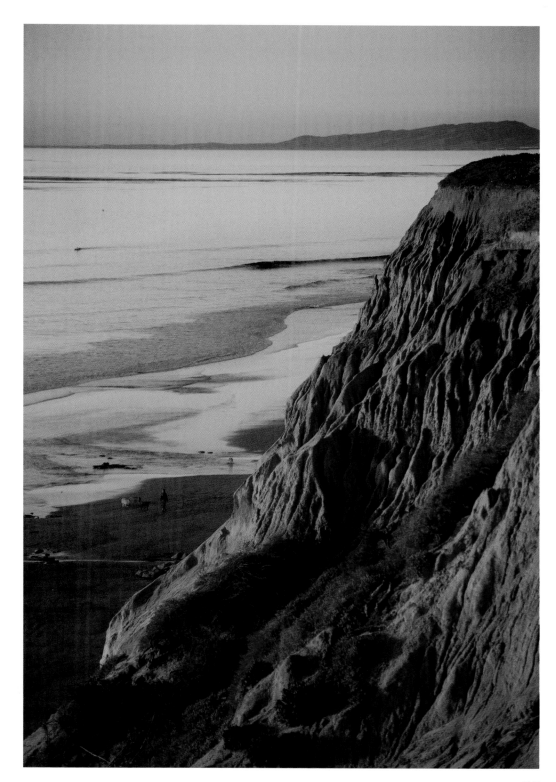

SOLANA SWELLS

Shaped by a light offshore wind, a perfect set of swells roll in to break on the sands of southern Solana Beach.

To see Aaron's story behind Solana Swells: AaronChang.com/Solana-Swells_blog

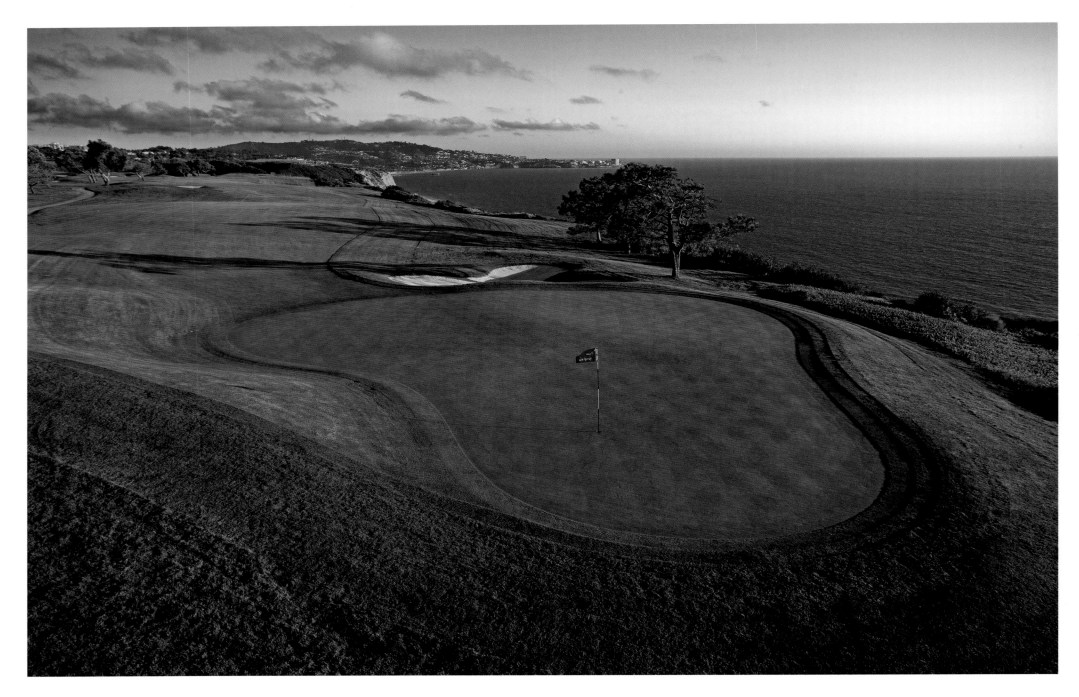

4ᵀᴴ HOLE, TORREY PINES

Host to the 2008 U.S. Open, this portrait of the famous 4ᵗʰ hole was shot the evening before the competition began. Torrey Pines is one of the most beautiful and challenging golf courses in the world.

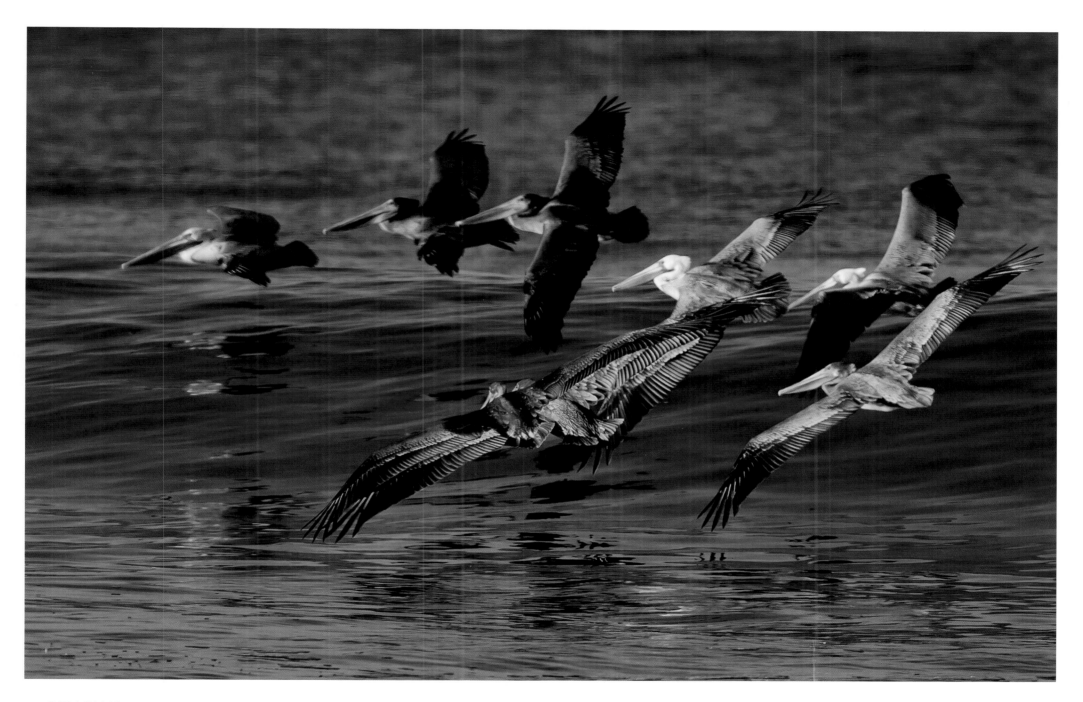

PELICANS

This is one of California's endangered species success stories. Pelicans hover over the waves during a morning flight.

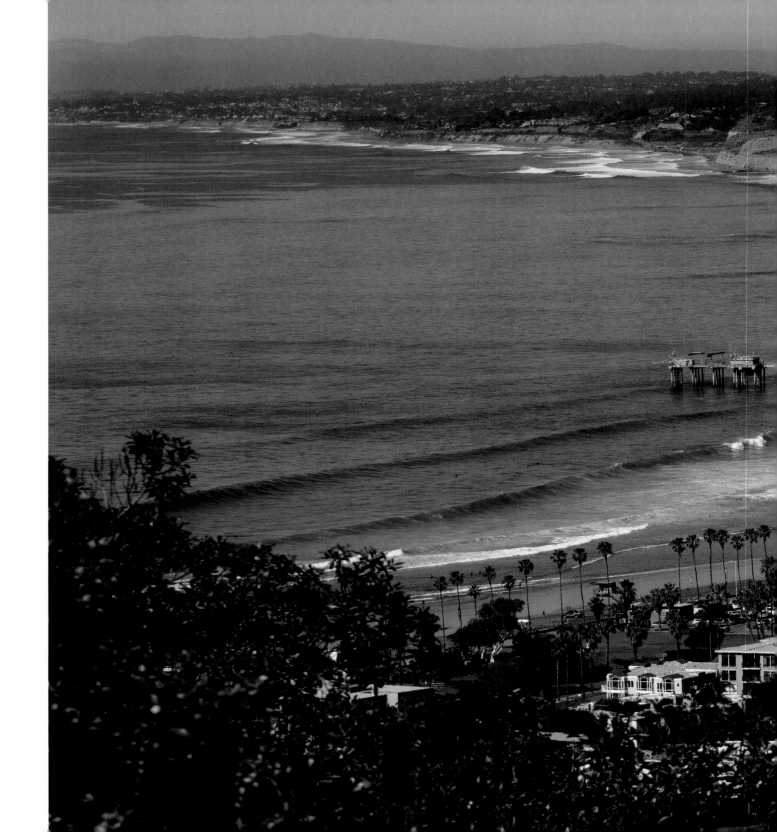

LA JOLLA SHORES

On a perfect winter day, with a light "Santa Ana" breeze, no other city in the continental U.S. can compete with the beauty of La Jolla, especially with a perfect ten foot swell breaking along the coast.

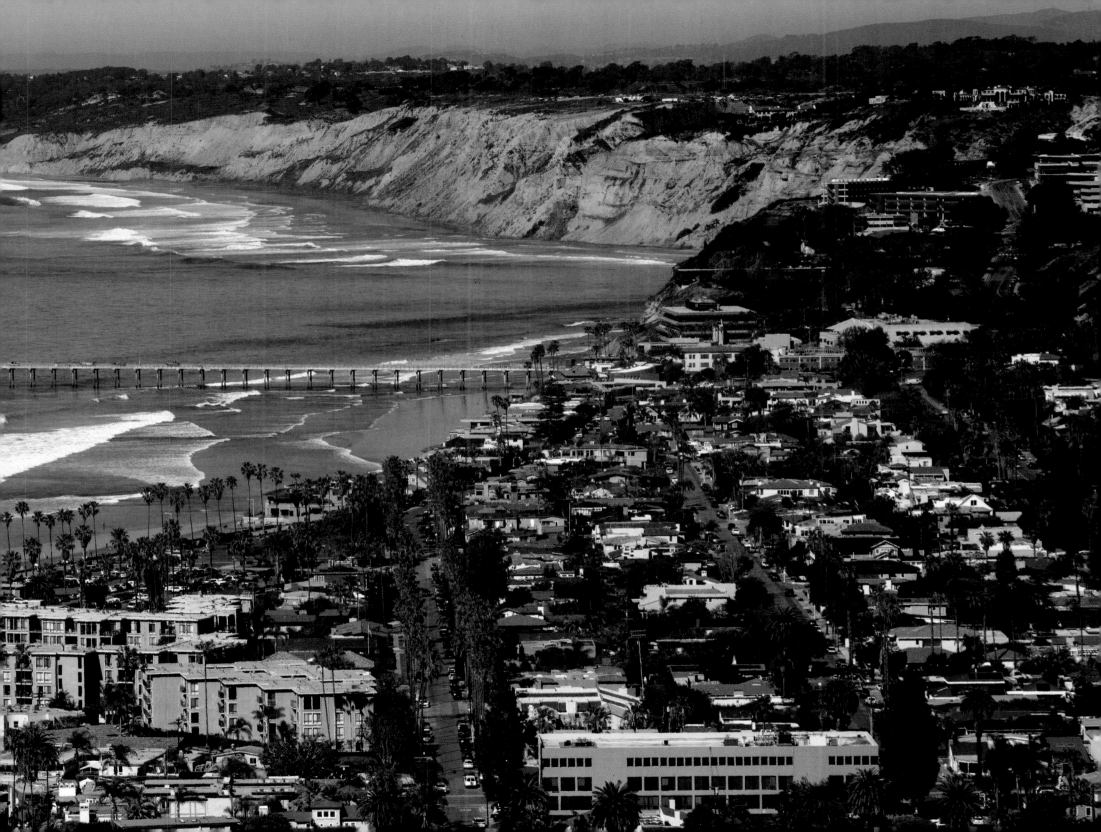

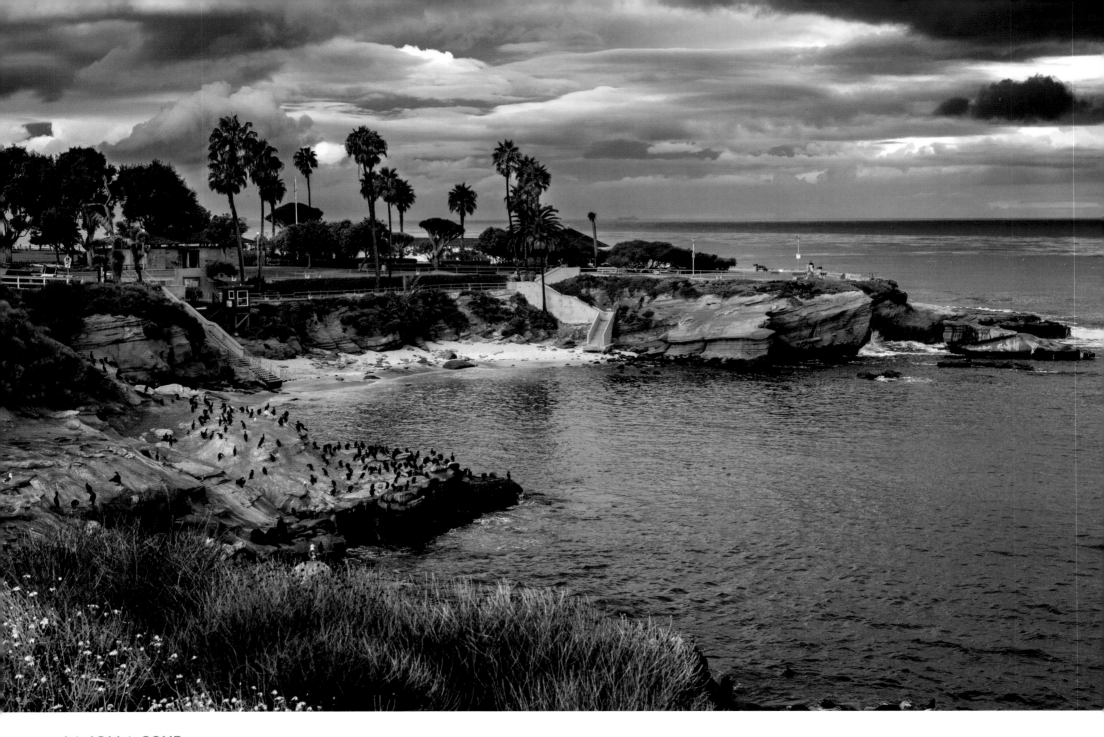

LA JOLLA COVE

La Jolla is a gem in the crown jewels of San Diego. This moody shot coveys the natural beauty that attracts visitors from around the world.

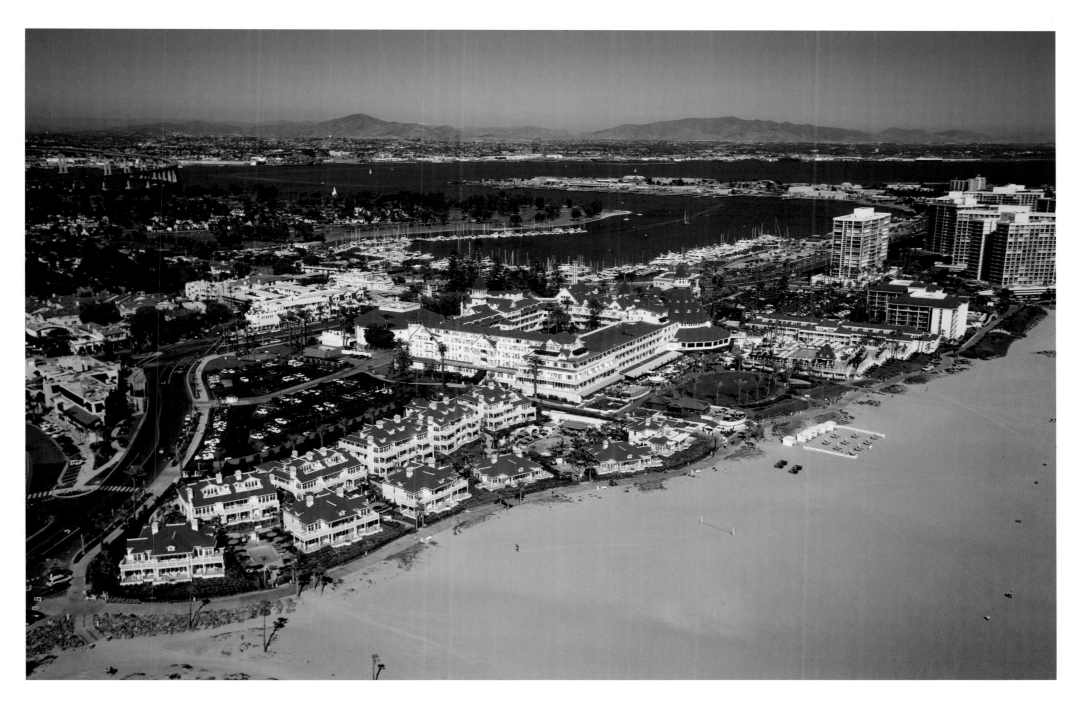

CORONADO AERIAL
Coronado's iconic landmark, Hotel Del Coronado, shot from a seagull's perspective.

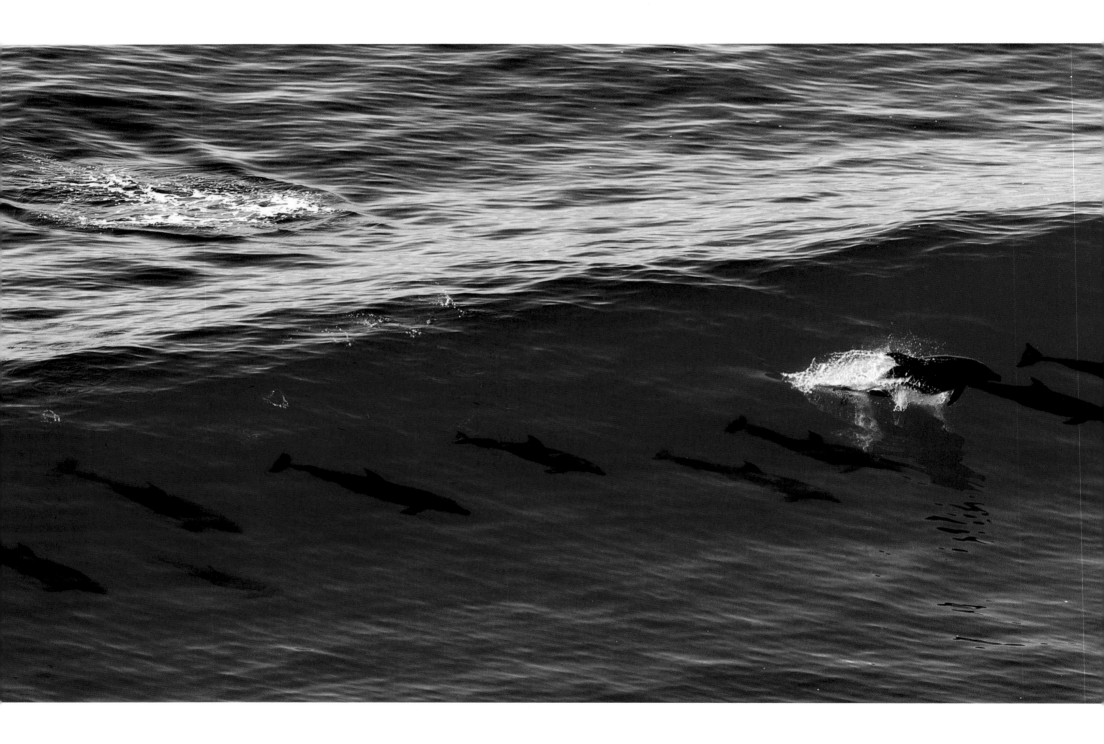

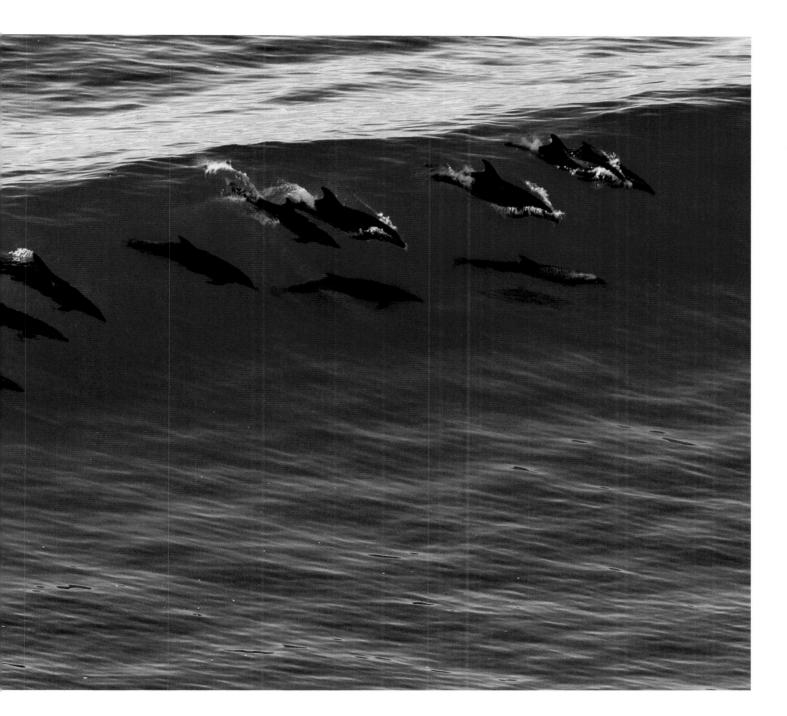

21 DOLPHINS
Dolphins bodysurf the shore-break off La Jolla in this playful panoramic shot. To hear Aaron's story about this shot, visit AaronChang.com/21-dolphins.

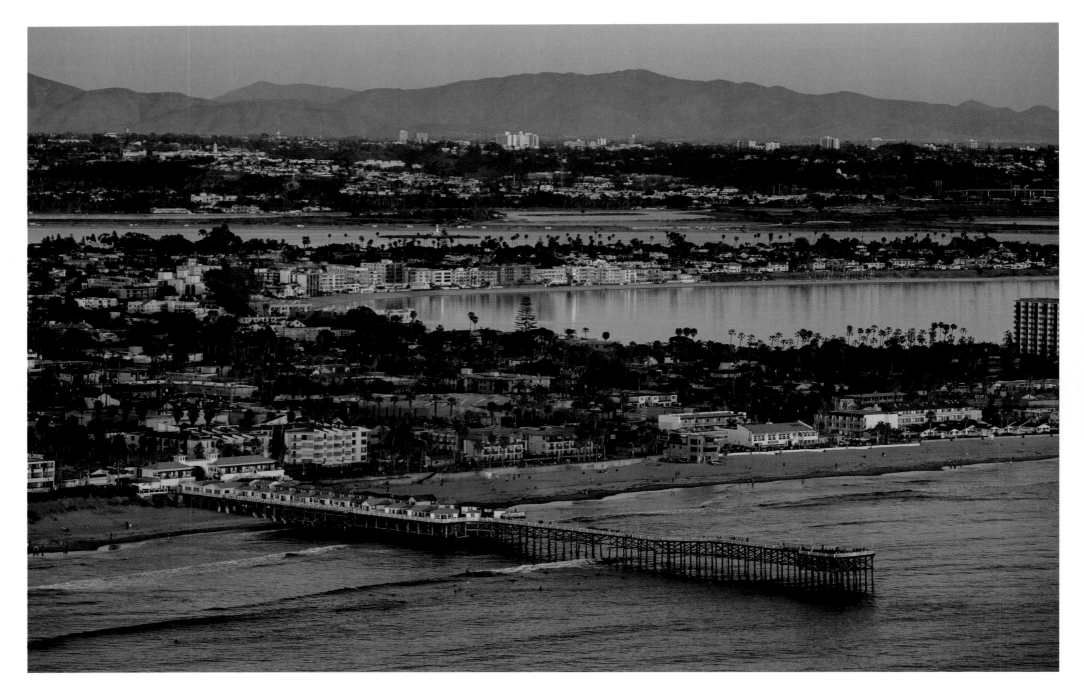

CRYSTAL PIER, PACIFIC BEACH

One of the few piers in California to offer over water lodging, Crystal Pier is a San Diego classic.

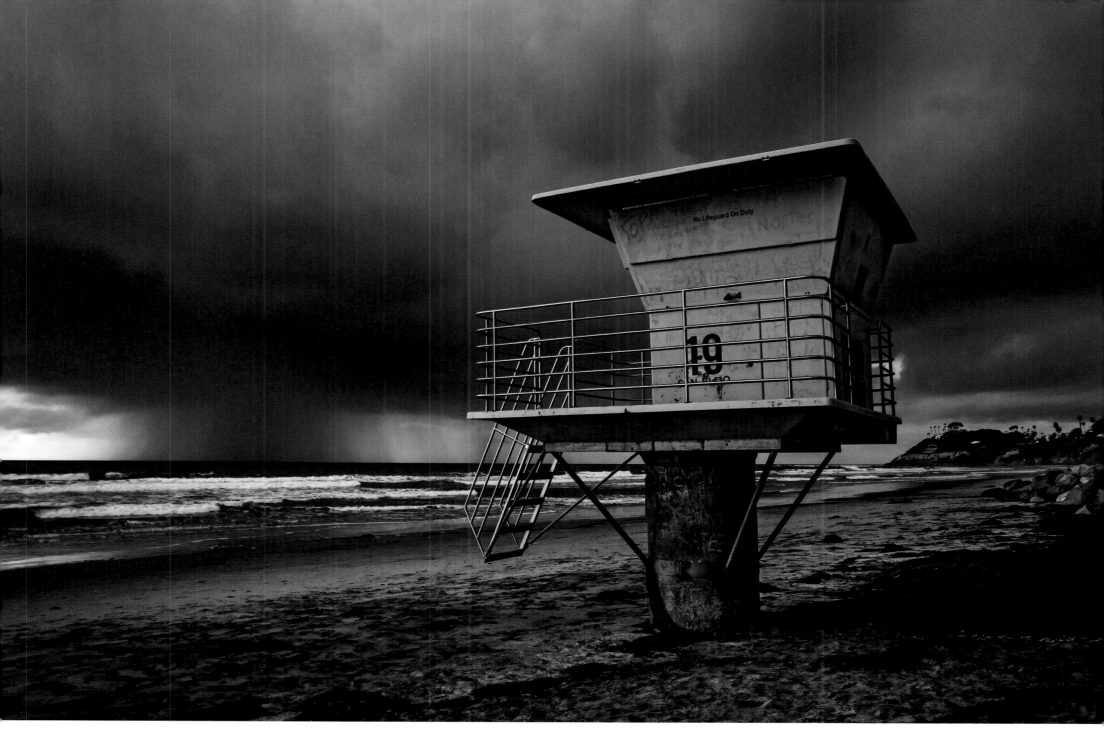

TOWER 19, ENCINITAS

The 19th lifeguard tower located near the San Elijo campground is symbolic of the San Diego beach lifestyle.

To see Aaron's Endless Summer video and Collection (contains Tower 19): AaronChang.com/endless-summer_blog

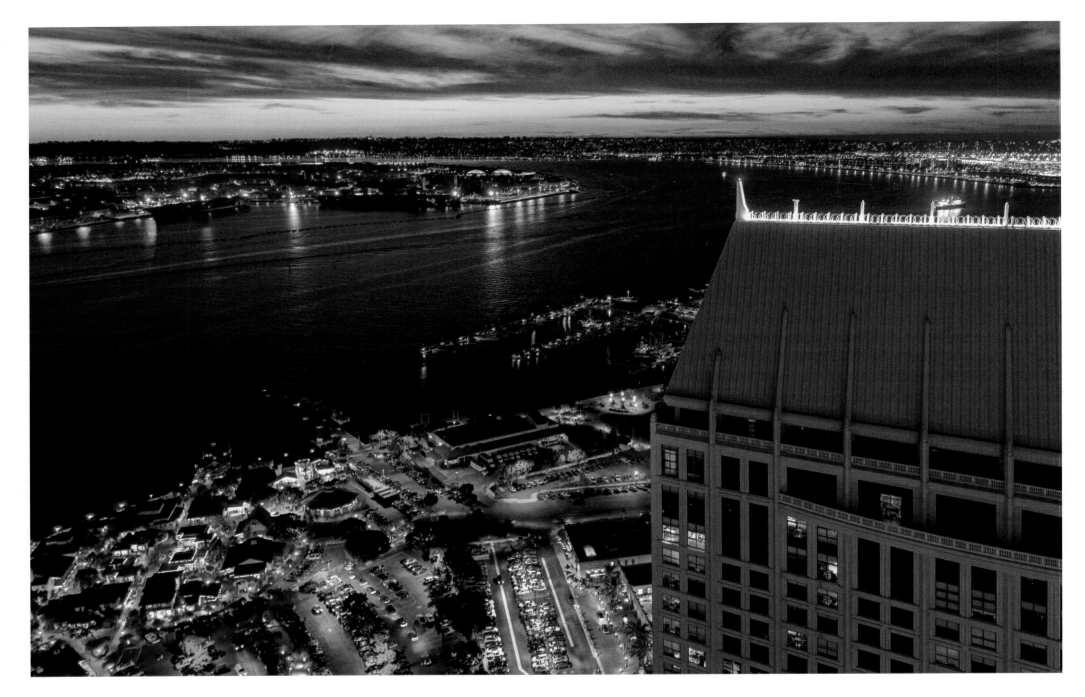

SAN DIEGO BAY SUNSET

Majestic views of the Embarcadero, Seaport Village, and the Headquarters—to Coronado... and beyond.
For info on Aaron's guided walking photo tour around San Diego bay, go to: AaronChang.com/photo-tour.

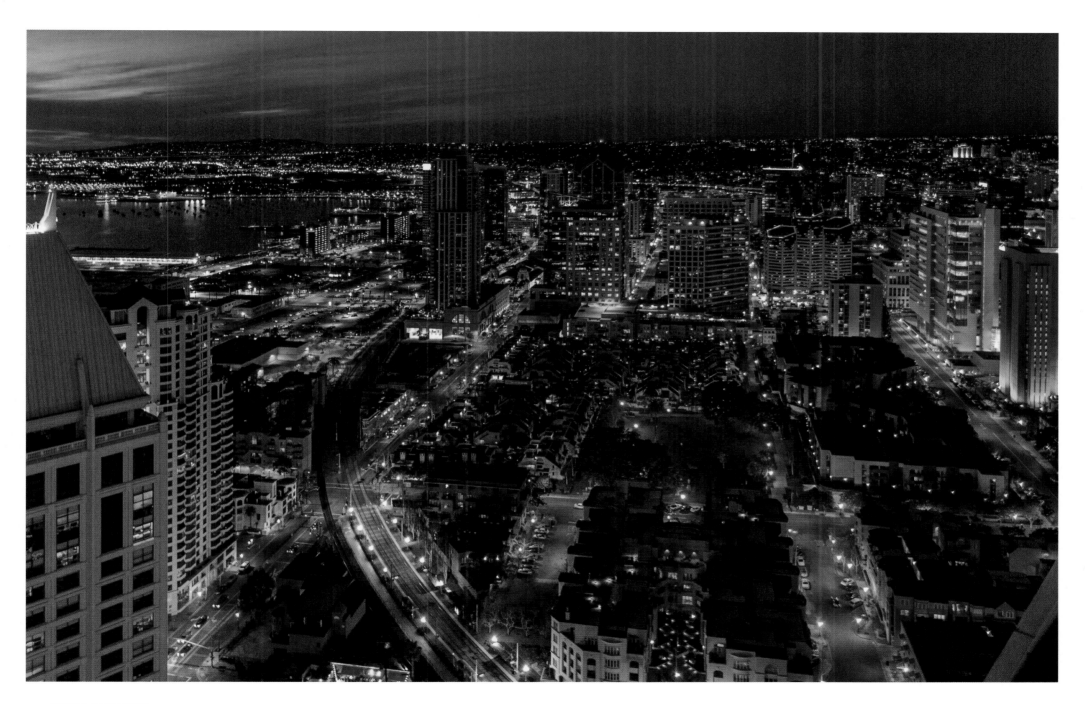

CITY SUNSET

The elegant city lights up like a jewel in the crown of San Diego.

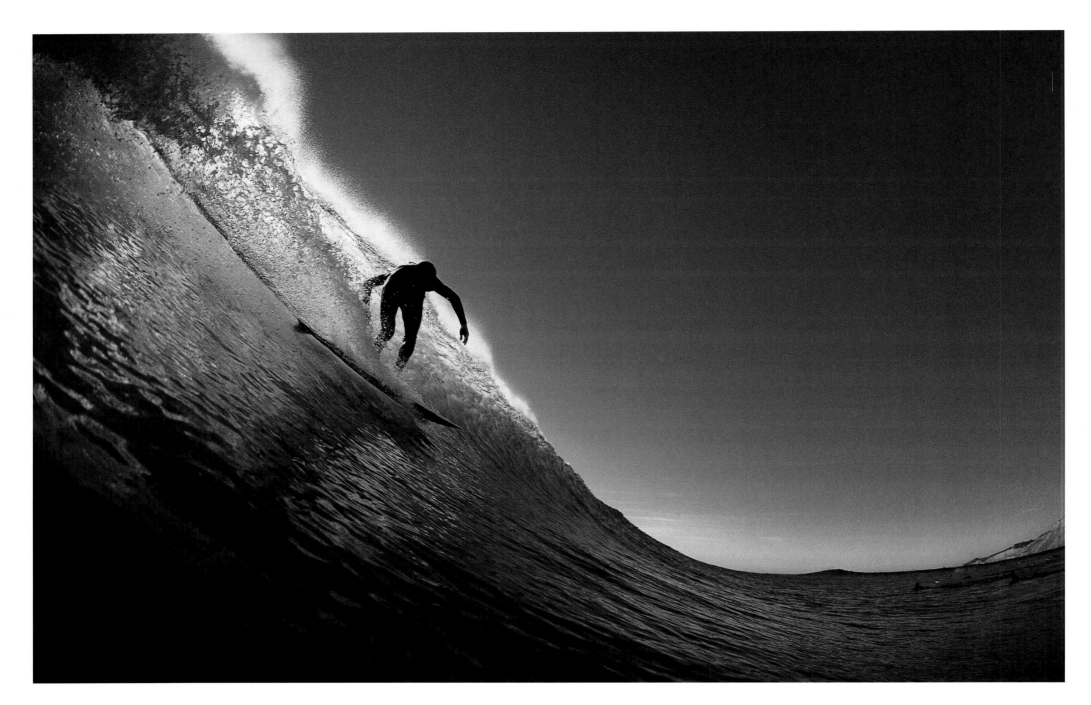

JOEL TUDOR, BLACK'S BEACH
Surfing legend and World Longboard Champion, Joel Tudor, drops into a perfect wave in La Jolla.

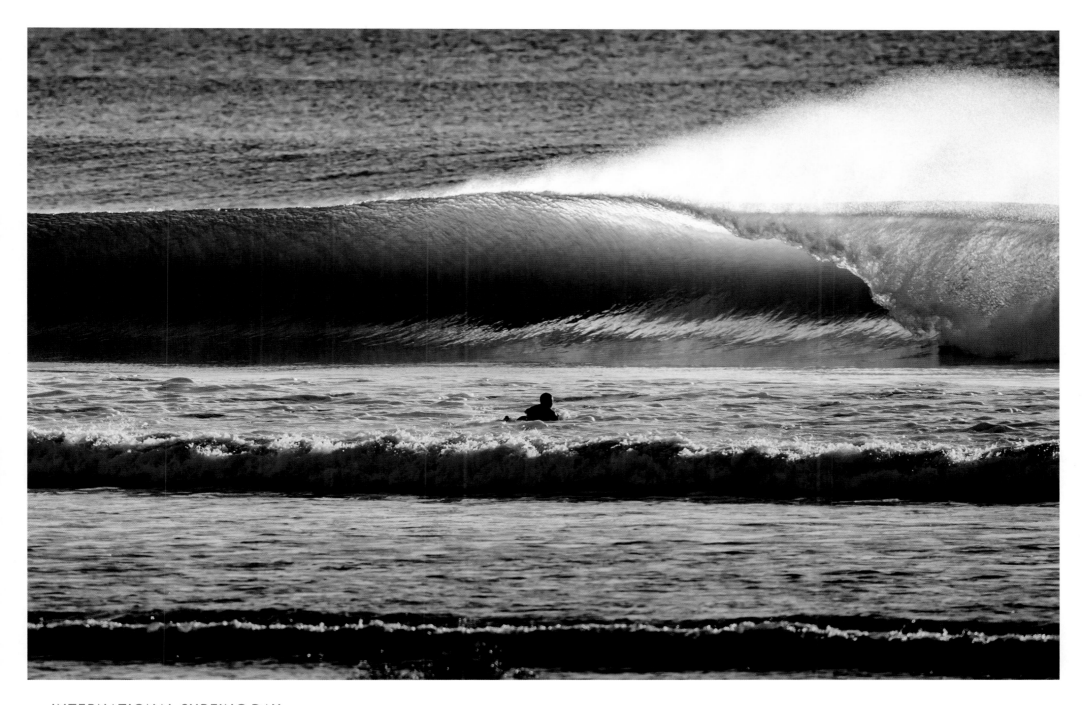

INTERNATIONAL SURFING DAY
Surfing Magazine used this photo, captured during a "Santa Ana" winter day, to promote and launch its inaugural International Surfing Day.
To see Aaron's slideshow of San Diego ocean and wave photography, go to: AaronChang.com/san-diego-photography.

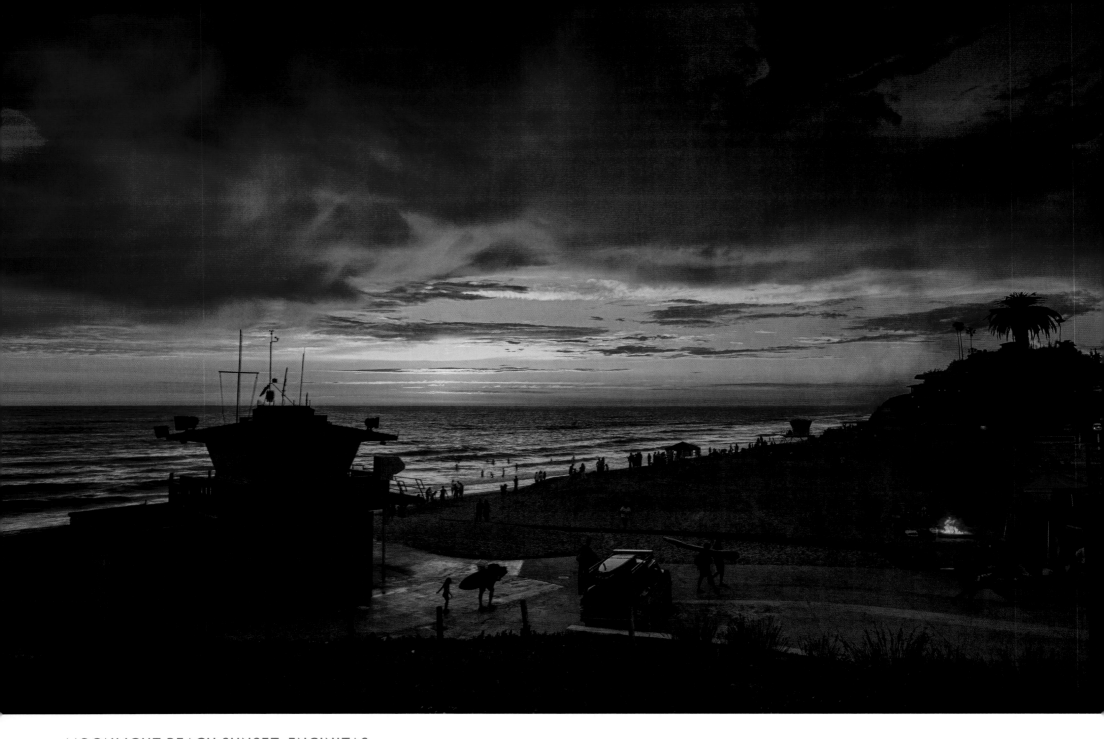

MOONLIGHT BEACH SUNSET, ENCINITAS

A hot, summer sun slips below the horizon, illuminating the sky and radiating the afterglow onto the scene unfolding at Moonlight Beach. The people and beauty of Encinitas come to life in this poignant photo that captures the essence of summer living in Southern California. To see Aaron's Endless Summer video and collection (contains Moonlight Sunset): AaronChang.com/endless-summer_blog

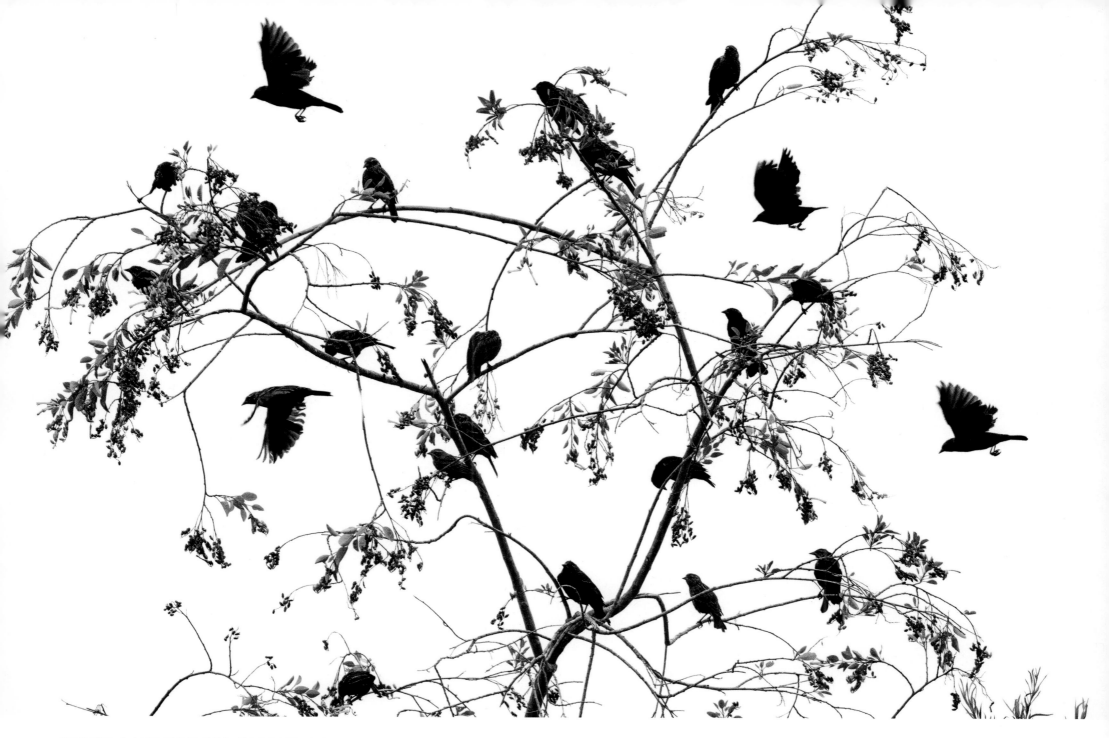

CROWS, LAKE HODGES, ESCONDIDO
Wild life and bird life abound in the San Dieguito River Valley Conservancy, which runs from Lake Hodges to Del Mar.

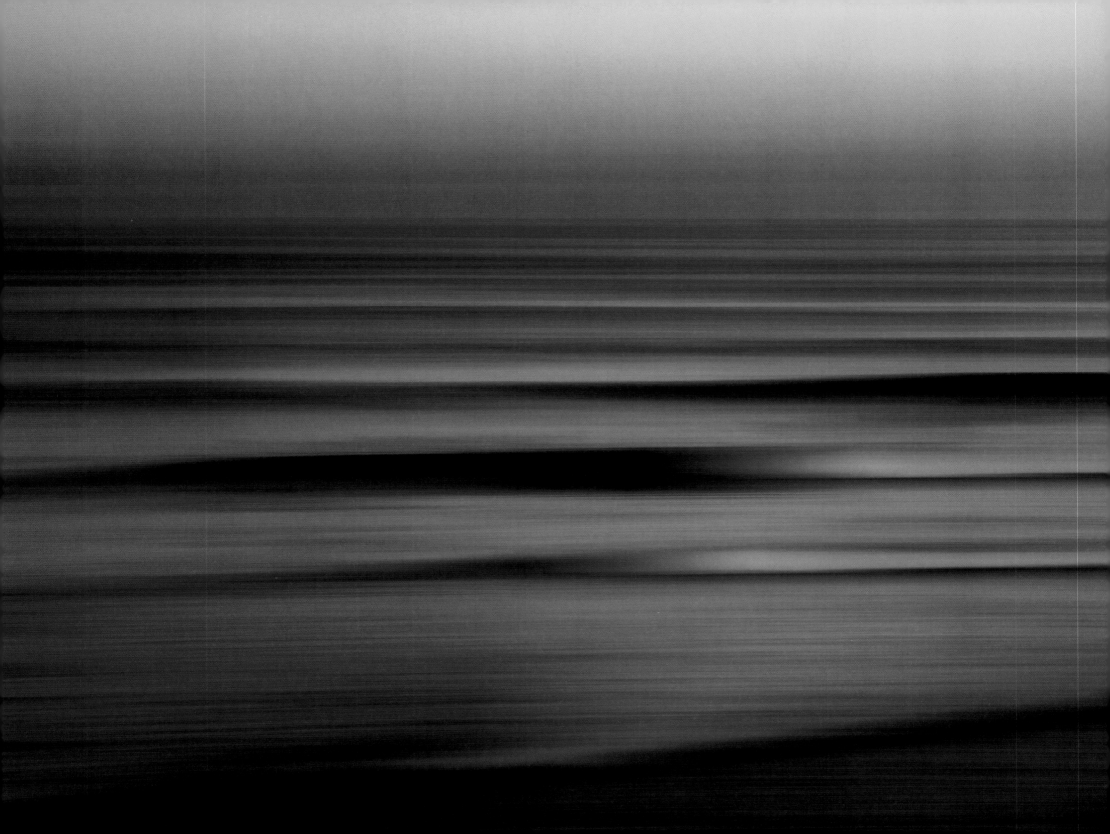

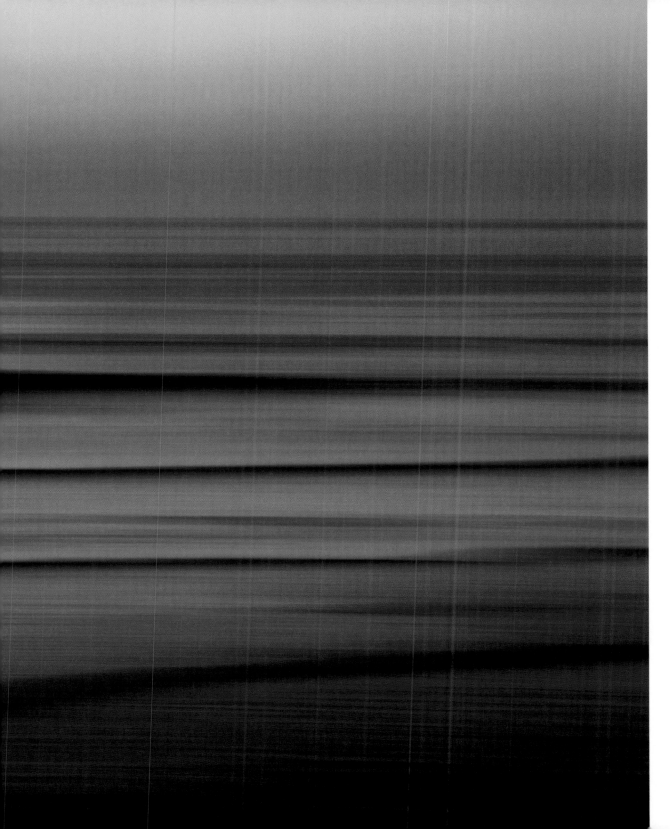

SERENITY, ENCINITAS

Swami's is the king of surf breaks in San Diego's North County. This predawn, abstract, line up shot captures a perfect set of ten foot waves peeling on the reef as the rising sun illuminates the western sky.

To see Aaron's video about the making of Serenity: AaronChang.com/Serenity_blog

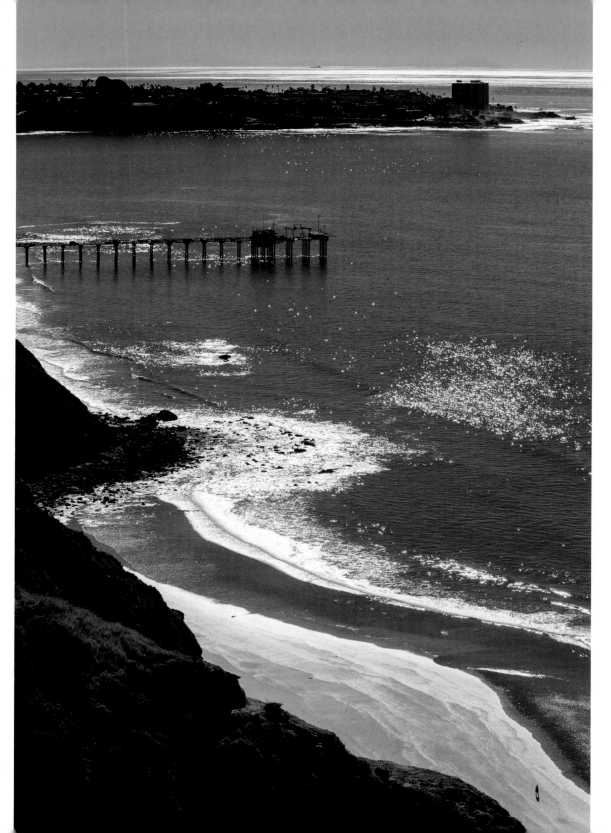

LA JOLLA CLIFFS

A sparkling, clear day silhouettes the town of La Jolla in the distance. The Scripps Pier, at La Jolla Shores beach, is an iconic landmark with rich surfing culture and history.

To see Aaron's slideshow of San Diego ocean and wave photography, go to: AaronChang.com/no-place-like-home.

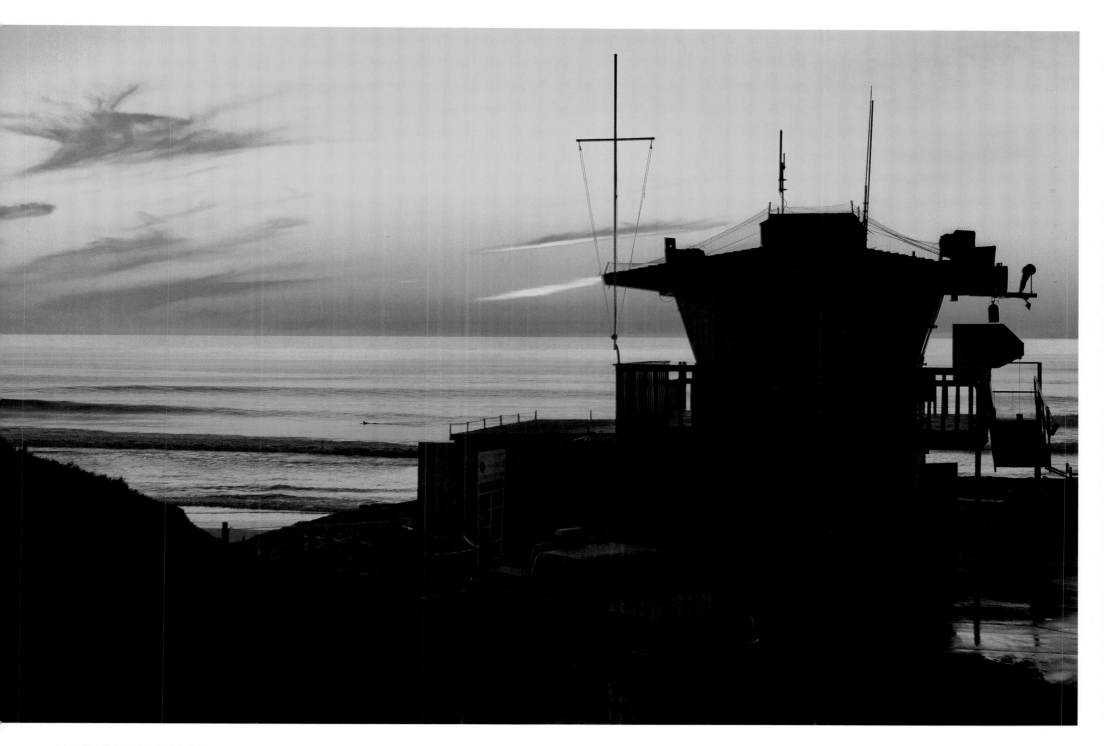

MOONLIGHT BEACH
The last rays of a long California summer day are captured in this classic sunset at the iconic lifeguard tower in Encinitas.

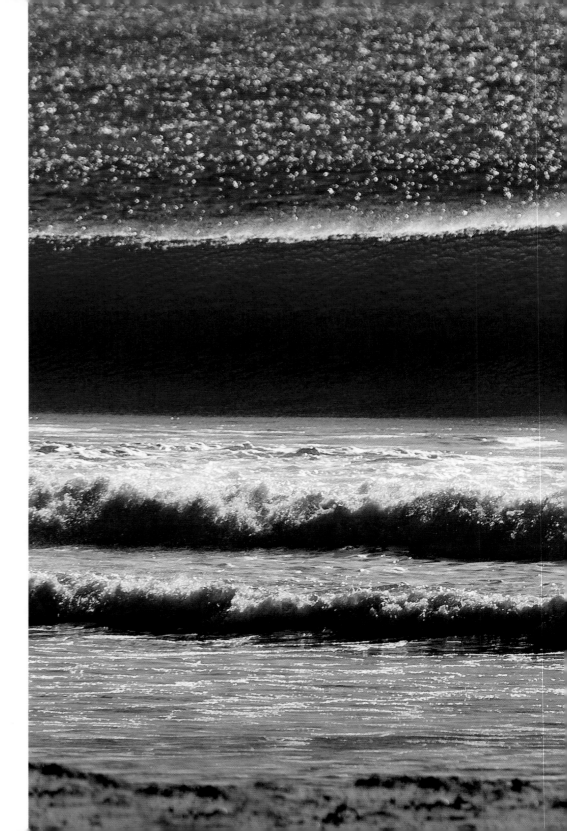

29TH STREET

The sun sparkles through the spray of an epic wave at Del Mar.

To see Aaron's story behind this shot, go to his behind-the-scenes video: AaronChang.com/surfing-magazine.

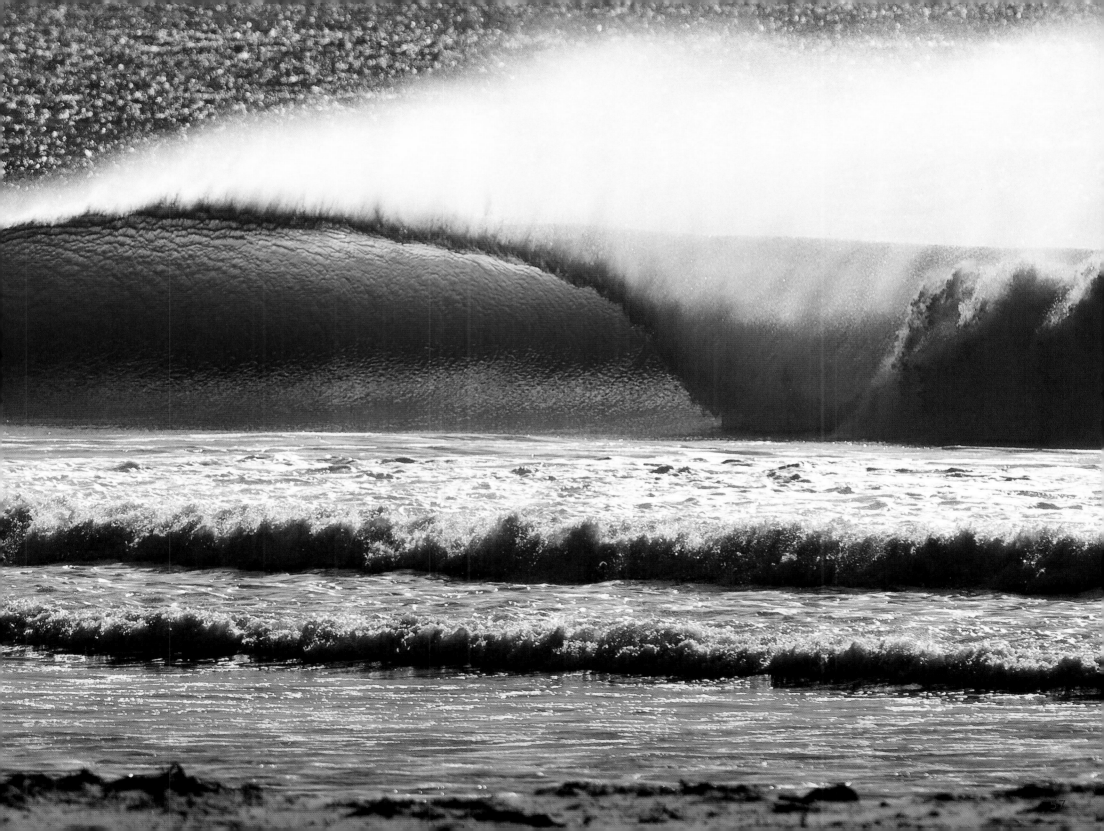

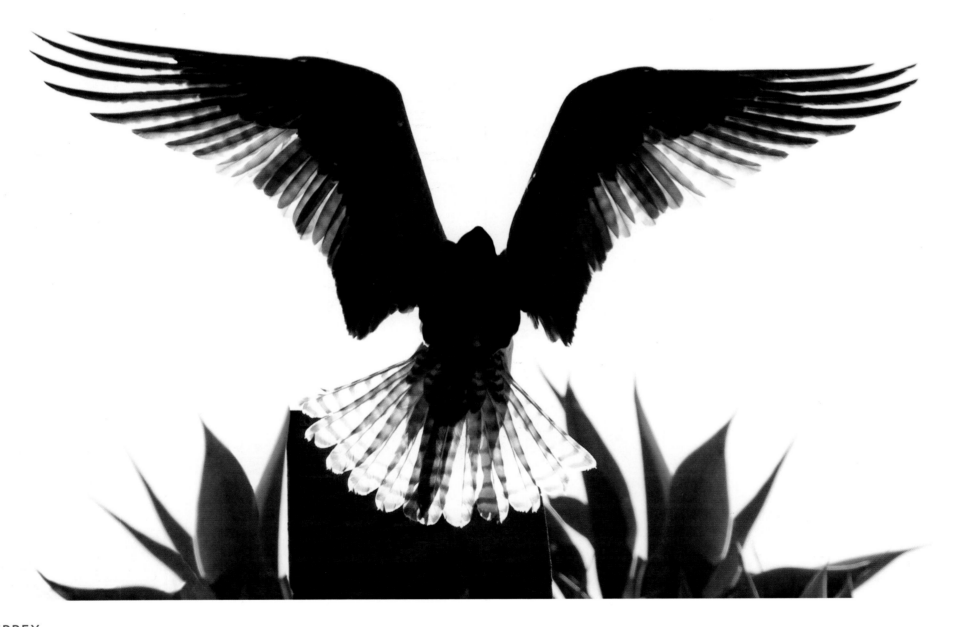

OSPREY

A California osprey spreads its wings. Majestic and beautiful, this sea hawk is captured taking flight in Cardiff-by-the-Sea, in North County.

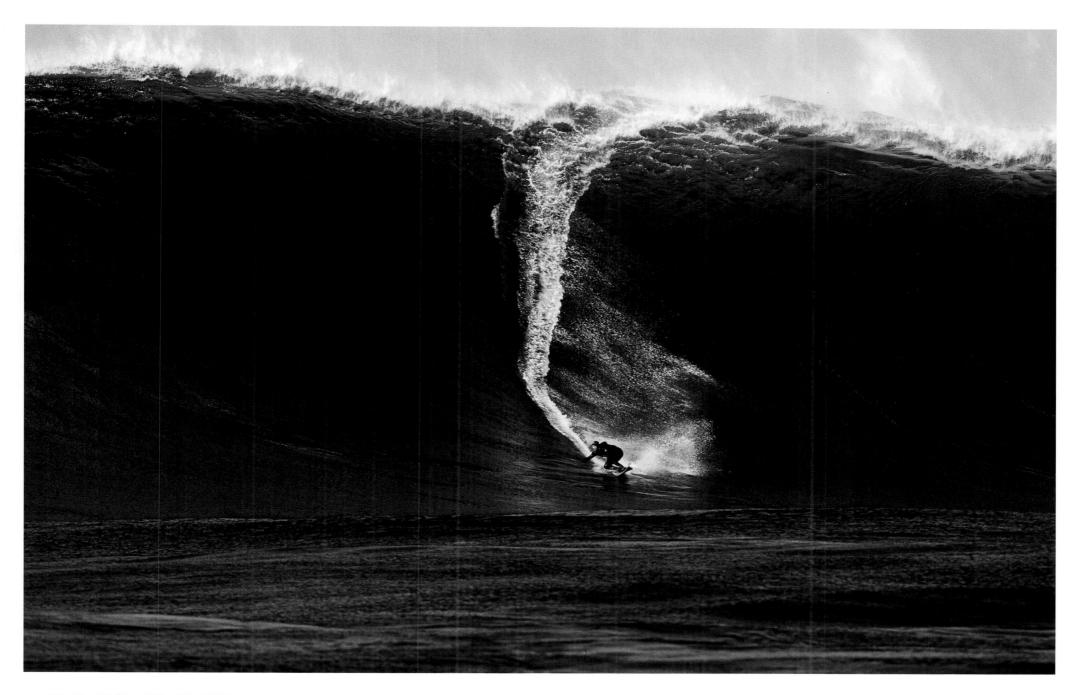

BRAD GERLACH, CORTES BANK

Local surfer, Brad Gerlach, drops into a huge wave at Cortes Bank, 100 miles due west
of San Diego. This break is considered to be one of the premier big-wave spots in the world.

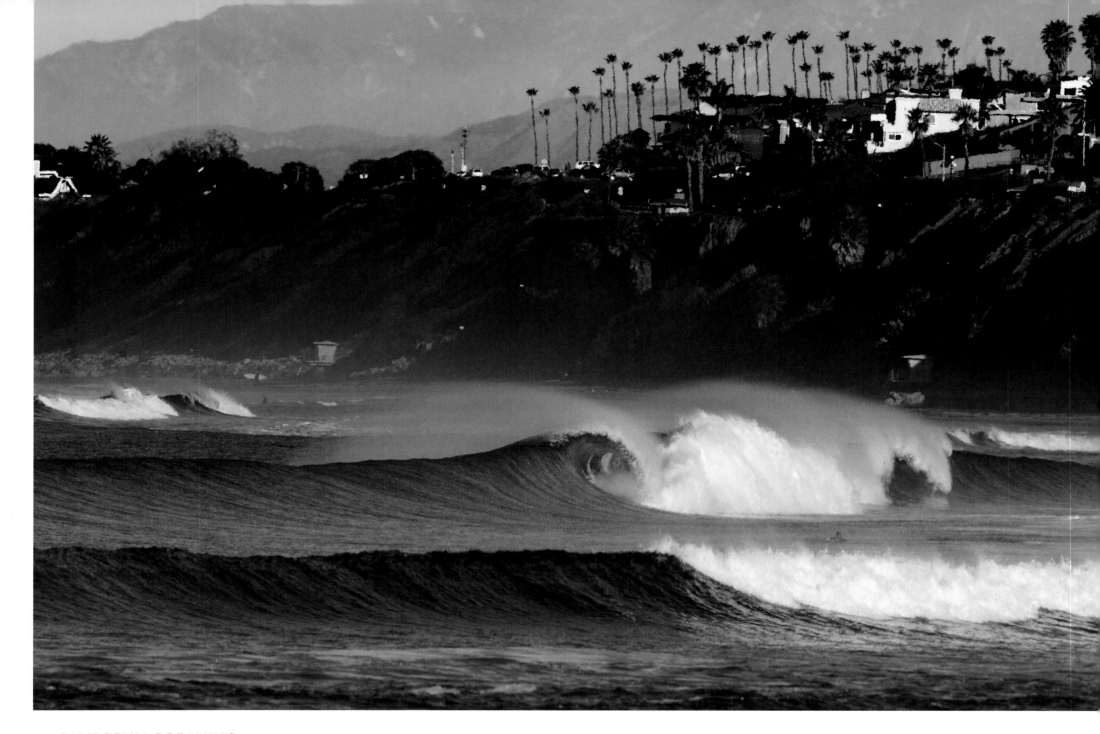

CALIFORNIA DREAMING
Palm trees dot the sandstone cliffs above the surf breaks between Solana Beach and Cardiff-by-the-Sea. To see Aaron's slideshow of San Diego ocean and wave photography, go to: AaronChang.com/no-place-like-home.

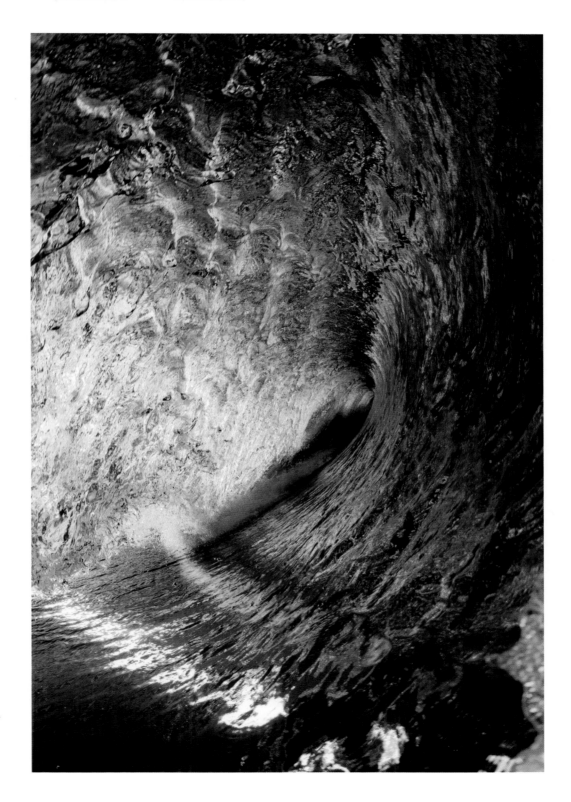

INDIGO WATER

This golden wave gets its glow from a sunrise in Del Mar on a crisp winter day. Using a camera in a water housing, Aaron shot this photo while swimming in the impact zone.

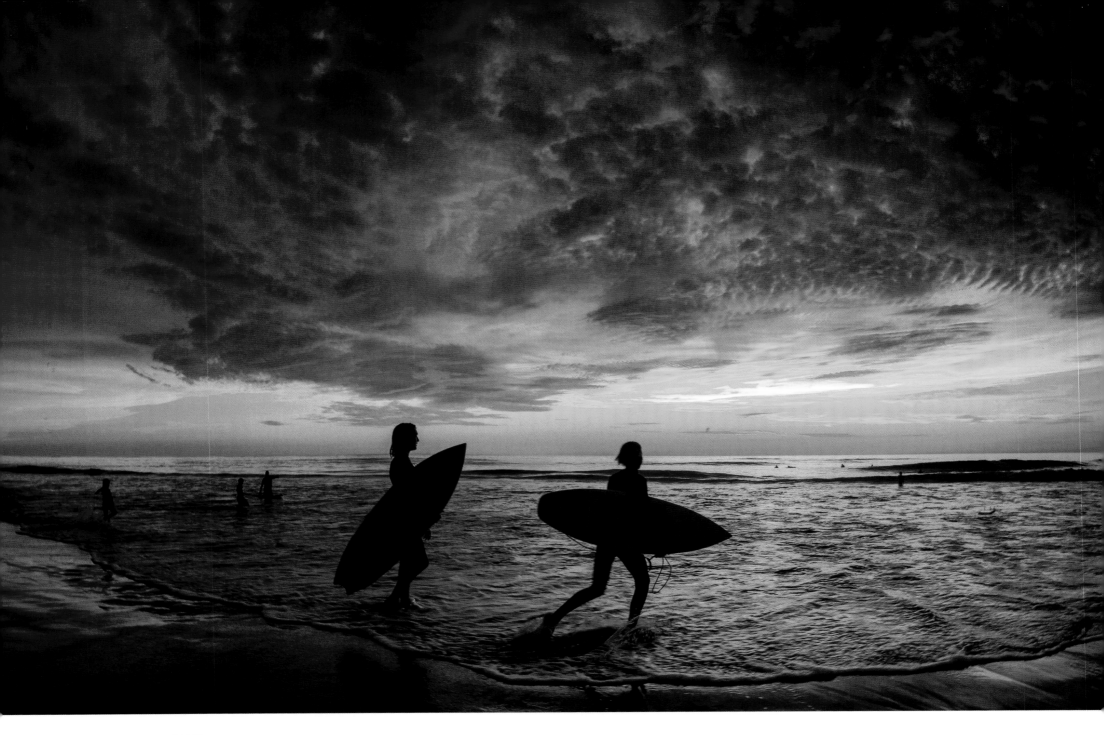

CARDIFF DELIGHT

Two surfers run out for the last wave of the day at Cardiff Reef, under a rare and dramatic tropical summer sunset.

To see Aaron's Endless Summer video and collection (contains Cardiff Delight): AaronChang.com/endless-summer_blog

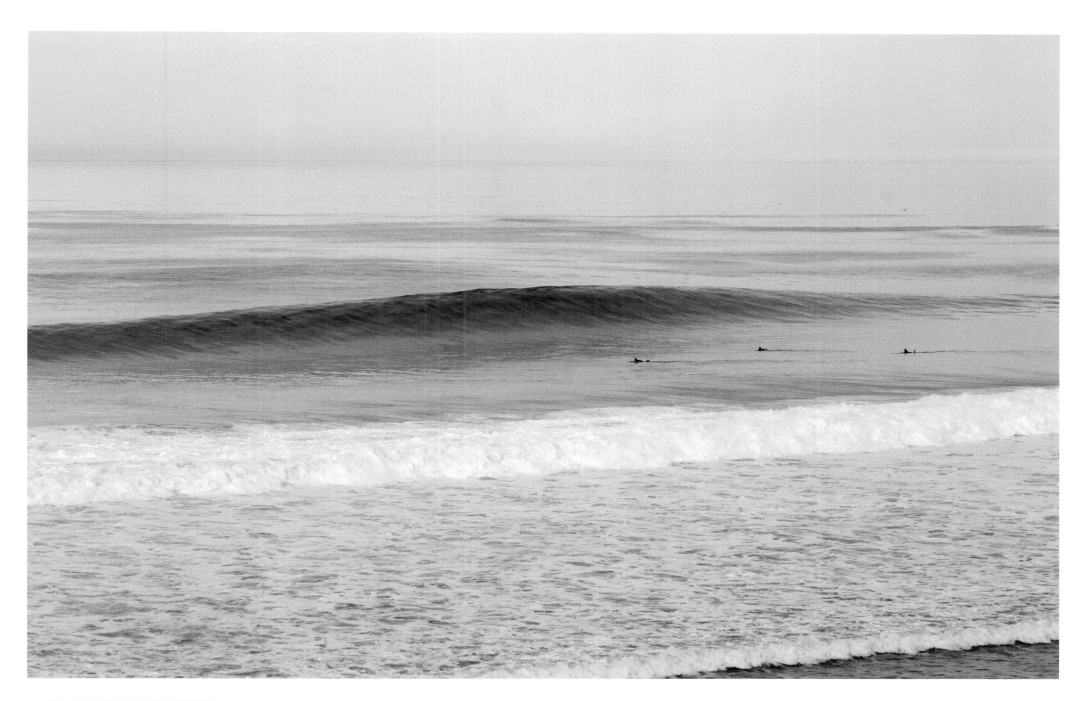

BLACK'S BEACH SWELL

Glassy waves in La Jolla during a clean north swell. Known as one of Southern California's finest waves, this image conveys the thrill of paddling into the surf.

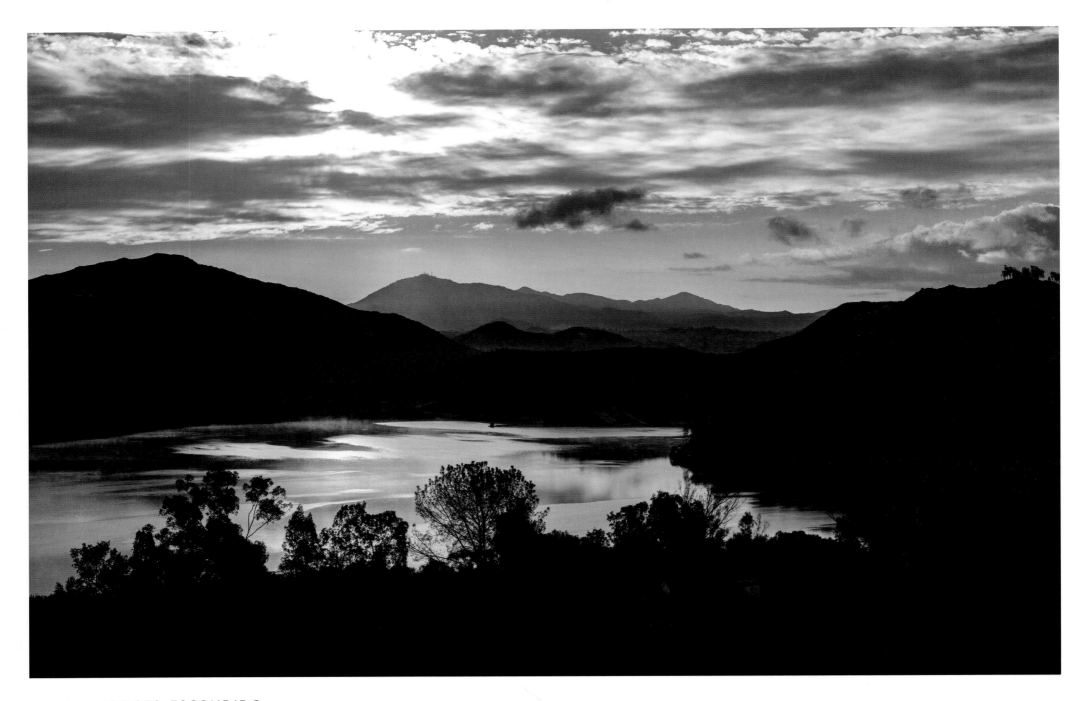

LAKE HODGES, ESCONDIDO
Nestled in the foothills of north San Diego county, Lake Hodges covers 1,234 acres. A great place to fish, the lake is home to bass, catfish, bluegill and carp. To see Aaron's San Diego Inland Collection, commissioned by Sharp Hospital Rancho Bernardo: AaronChang.com/san-diego-inland

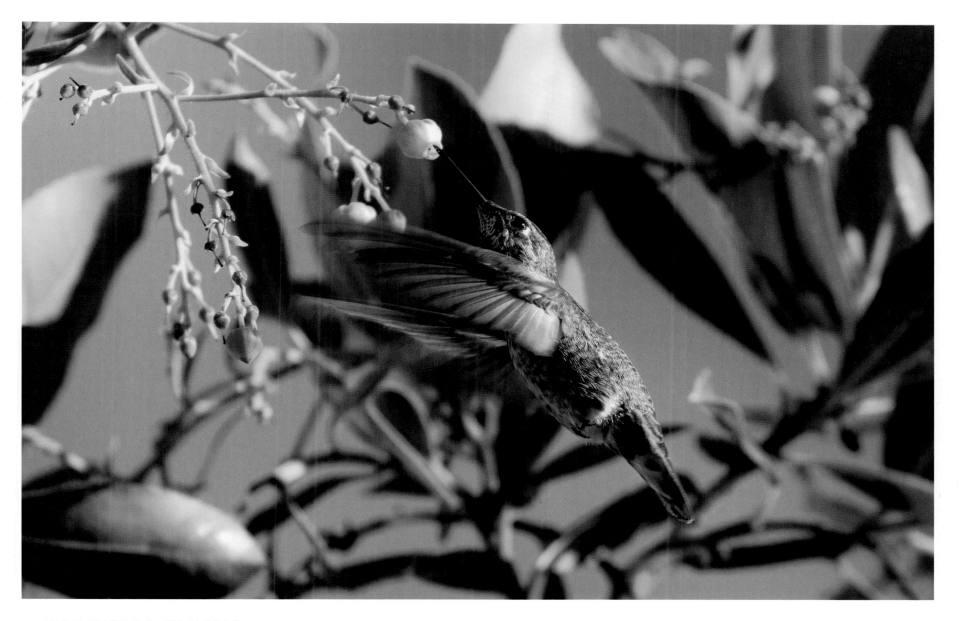

HUMMINGBIRD, CARLSBAD
One of the hardest creatures to photograph, this Anna's hummingbird feeds on nectar, while his wings beat at 50 flaps per second.

SWAMI'S SUNSET

This iconic stretch of Highway 101 winds along the beach through Encinitas on a warm summer night.

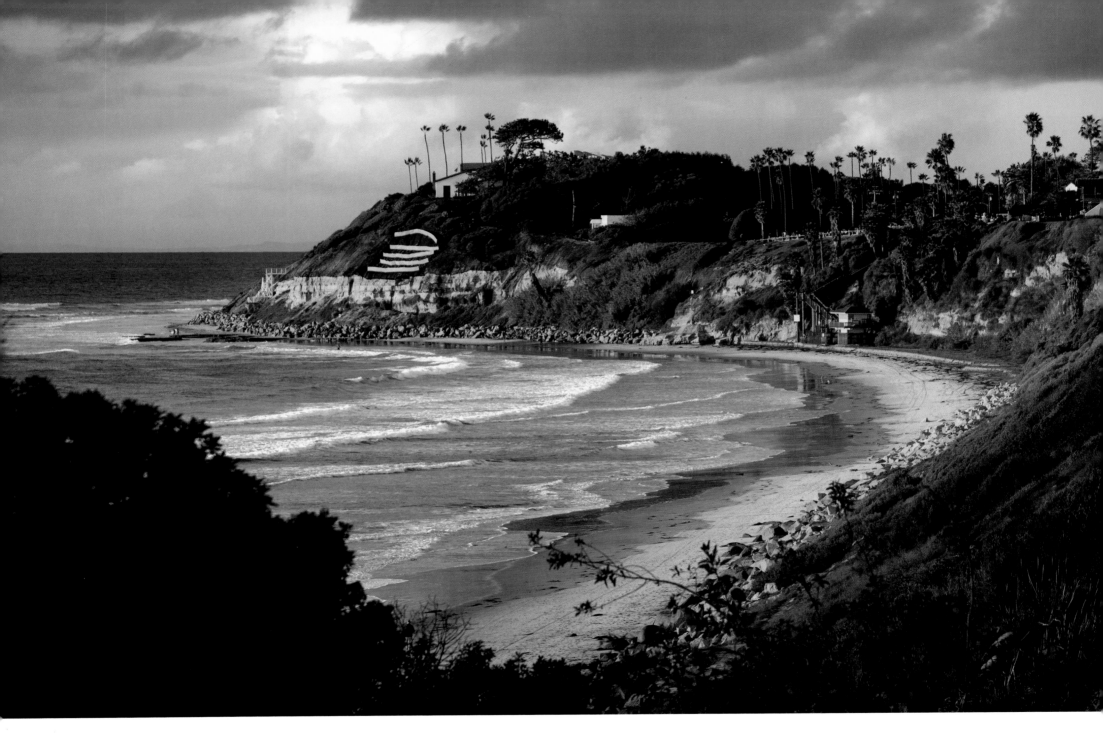

SWAMI'S HEADLAND

Golden light bathes this sleepy coastal community in a rich glow. A gentle surf break comes to life during winter swells.

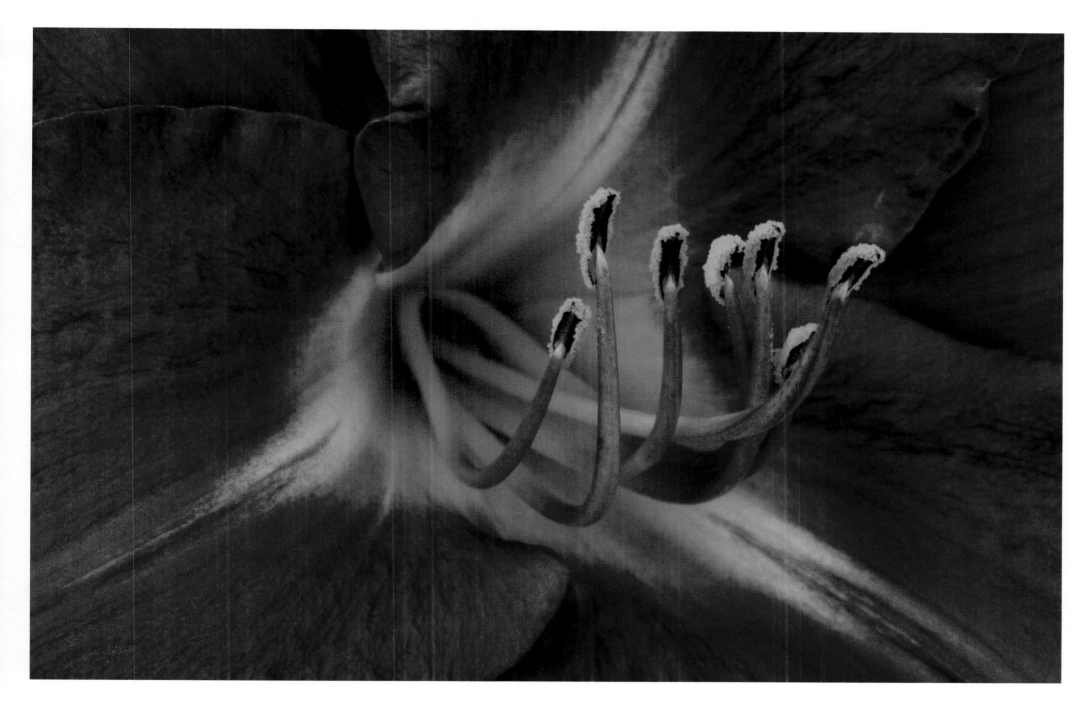

FLOWER PISTIL

A pink and yellow flower is loaded with delicate pollen in this abstract beauty shot.

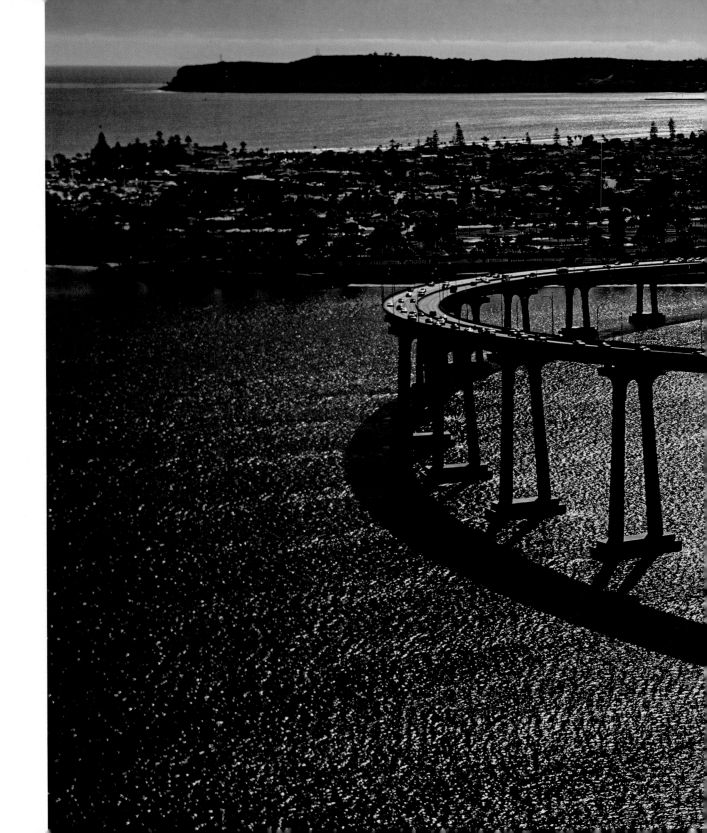

CORONADO BRIDGE

The modern lines of Coronado Bridge, connecting San Diego to the resort island, cast a dramatic shadow on the textured water below. Point Loma can be seen in the distance as well as Coronado's world famous beach.

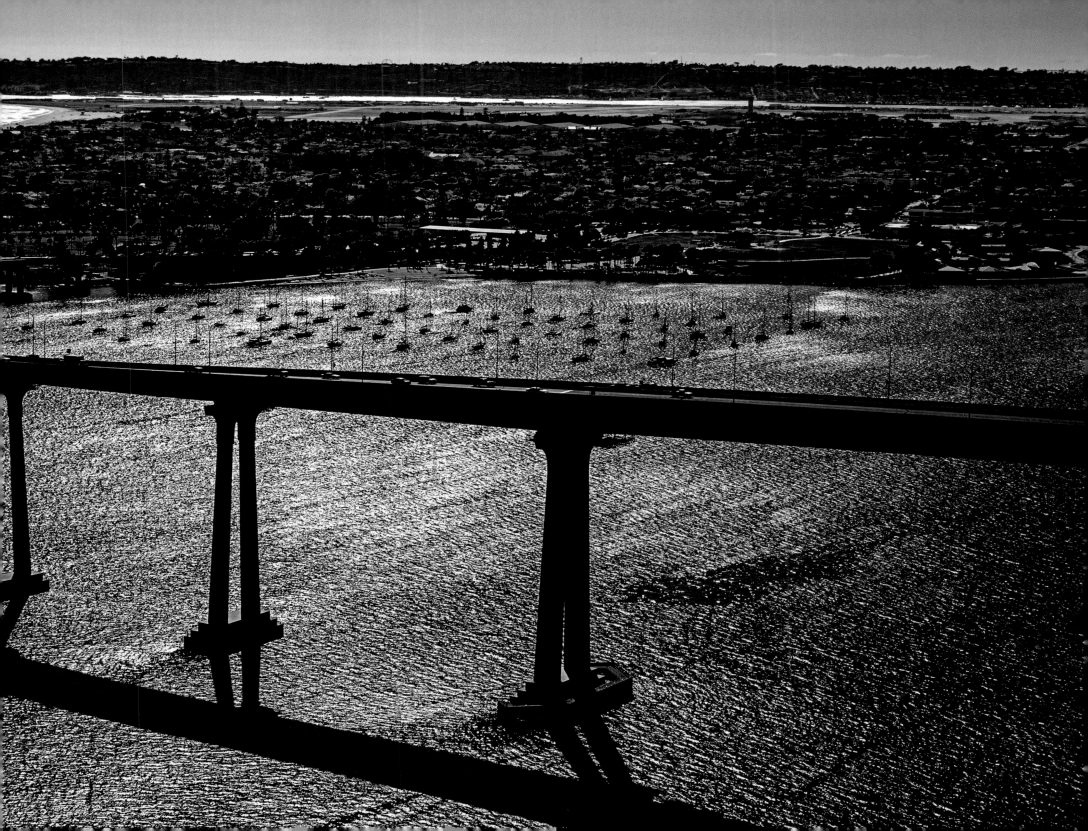

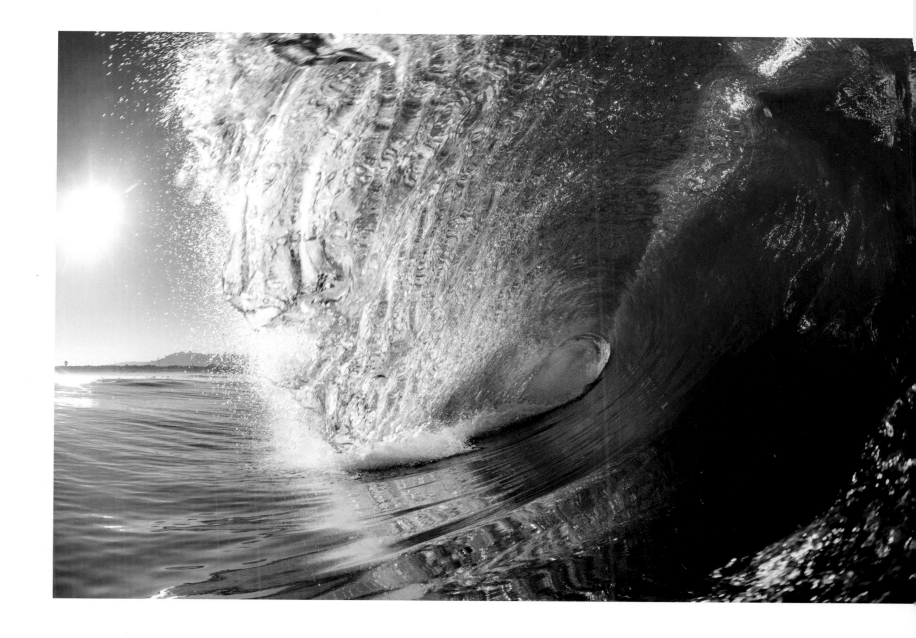

CARDIFF SPLENDOR
Shot in front of Cardiff's restaurant row, this tucked away beach break is a favorite for the local surfers on the high tide and a west swell.

BLUE VELVET
The moon slinks over the ridge in the Torrey Pines State Reserve in this masterpiece of light and shadows. The silhouetted Torrey Pines are the most rare pine species in the U.S., growing only in San Diego County and on one of the Channel Islands. To see Aaron's video about this shot, visit AaronChang.com/blue-velvet.

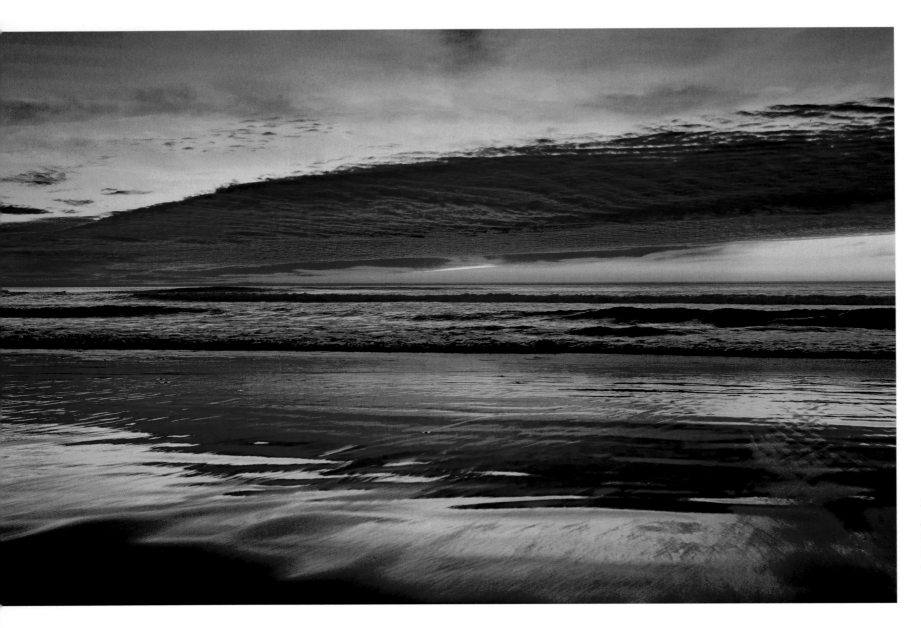

SEASIDE SUNSET

A magnificent study
in color and texture at
Seaside Reef in Cardiff-by-
the-Sea on a winter day.

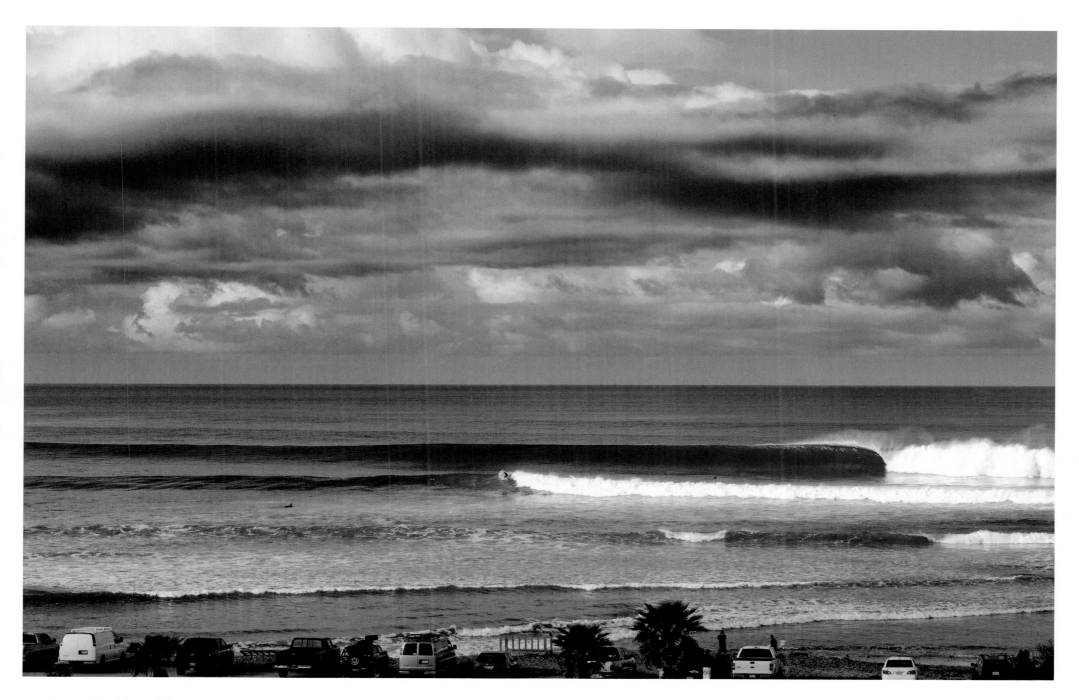

CARDIFF LINE-UP

Clean emerald waves break at Cardiff-by-the-Sea, as lazy tropical clouds glide past. Most locals remember this day clearly.

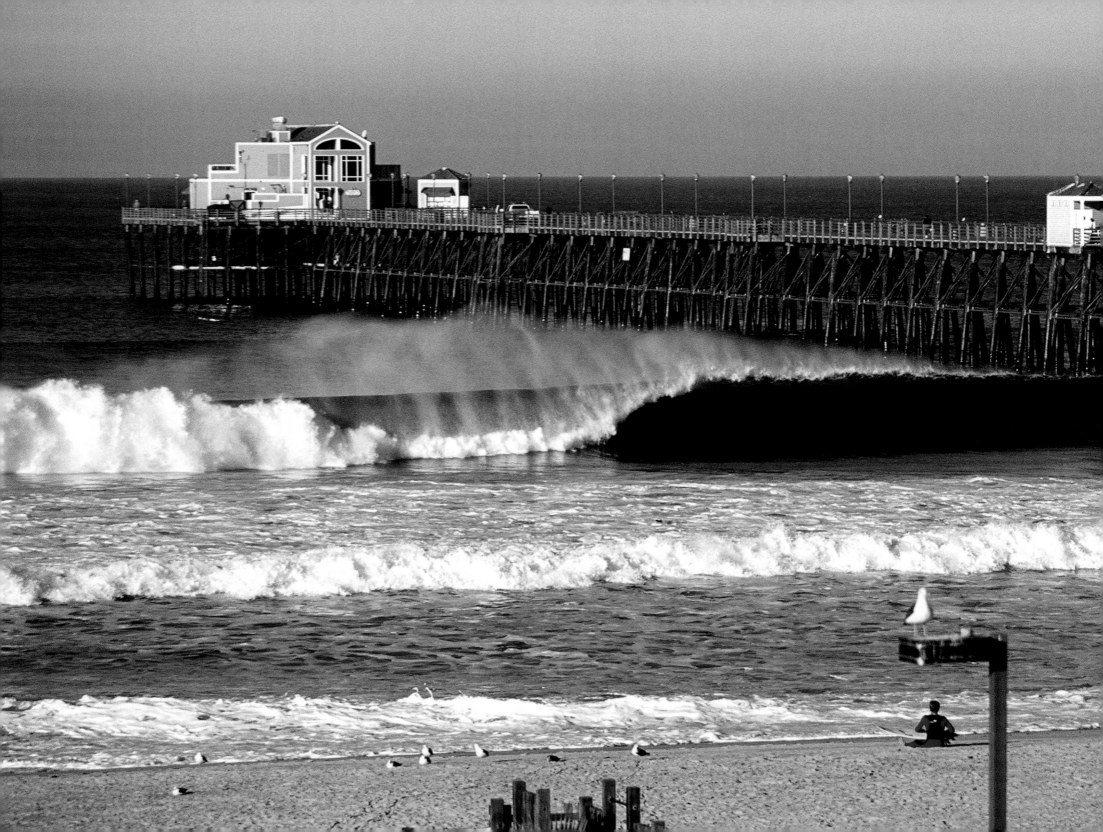

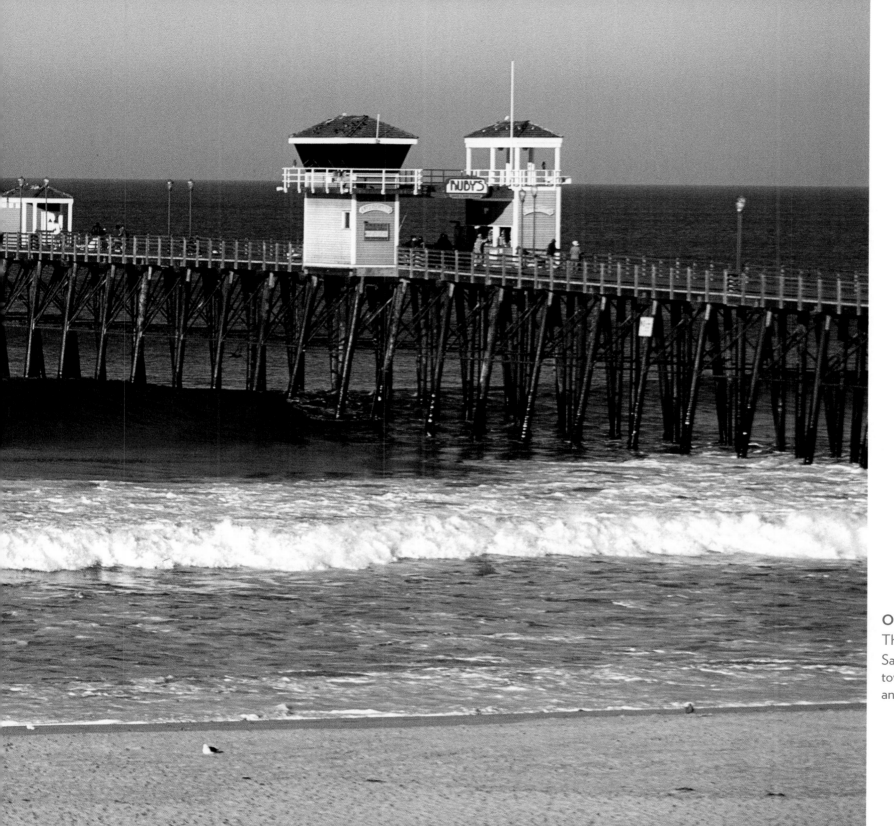

OCEANSIDE PIER

This northernmost
San Diego county beach
town is famous for its pier
and great surf.

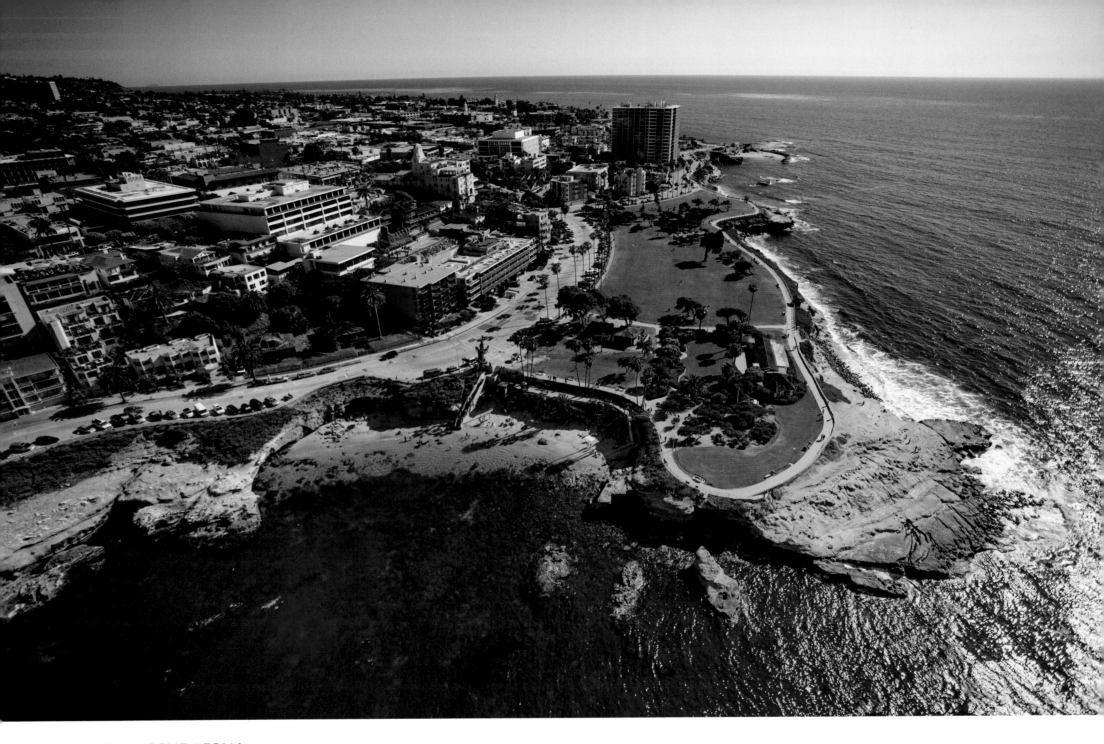

LA JOLLA COVE AERIAL

A birds-eye view of the iconic rocks and reef.

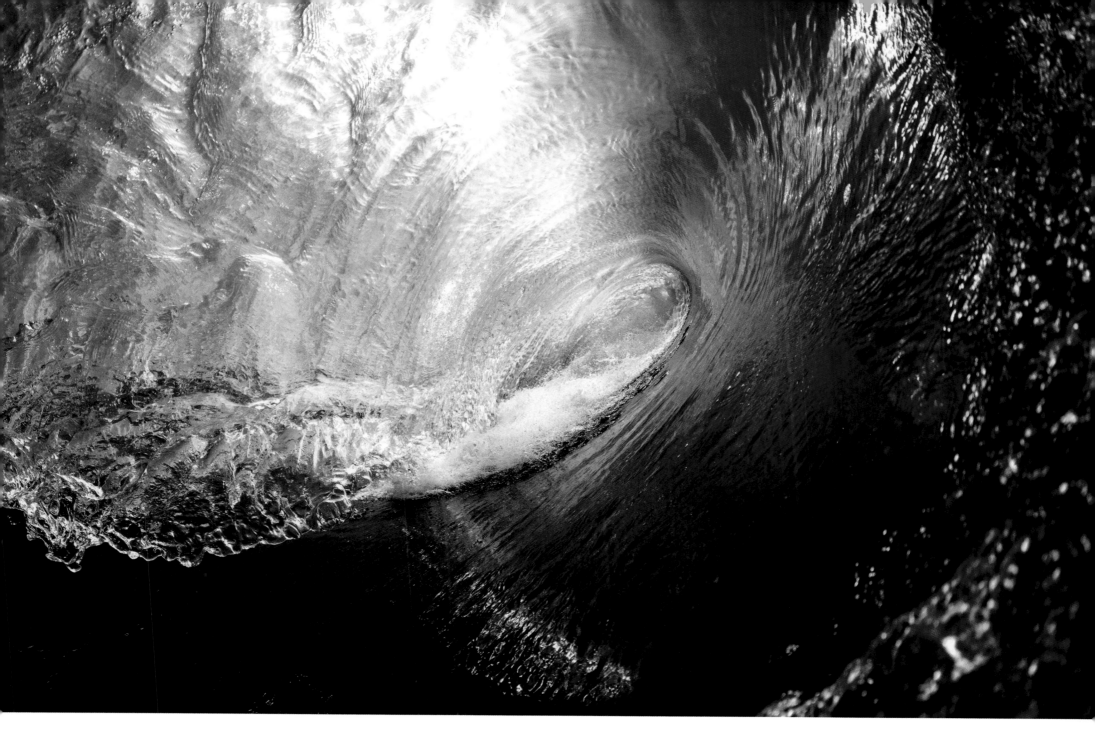

SUBLIME, CARLSBAD

Arcing wave from a beautiful late summer south swell off Carlsbad. Frozen in time, the water
in the lip of the wave becomes a crystal sculpture. Shot at Ponto Beach in South Carlsbad.

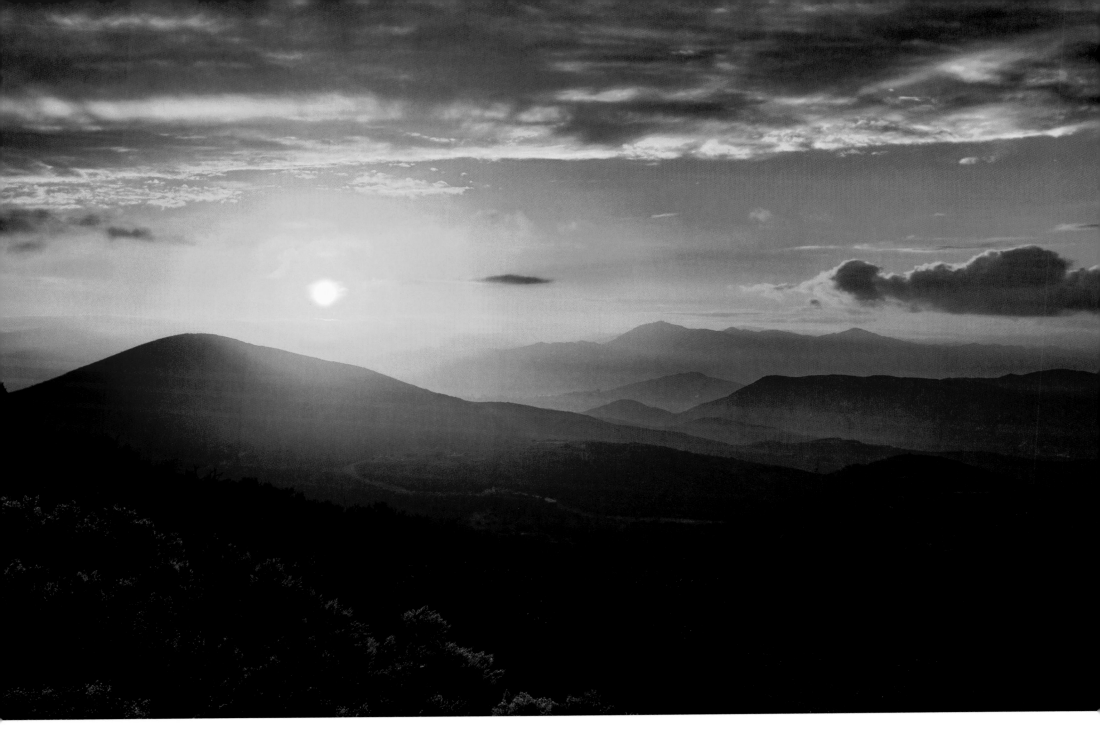

SUNRISE OVER RANCHO BERNARDO
This blazing sunrise was shot from atop Double Peak Park in San Marcos whose summit is 1,646 feet above sea level. This fall time vista is looking southeast over Rancho Bernardo.
To see Aaron's San Diego Inland Collection, commissioned by Sharp Hospital Rancho Bernardo: AaronChang.com/san-diego-inland

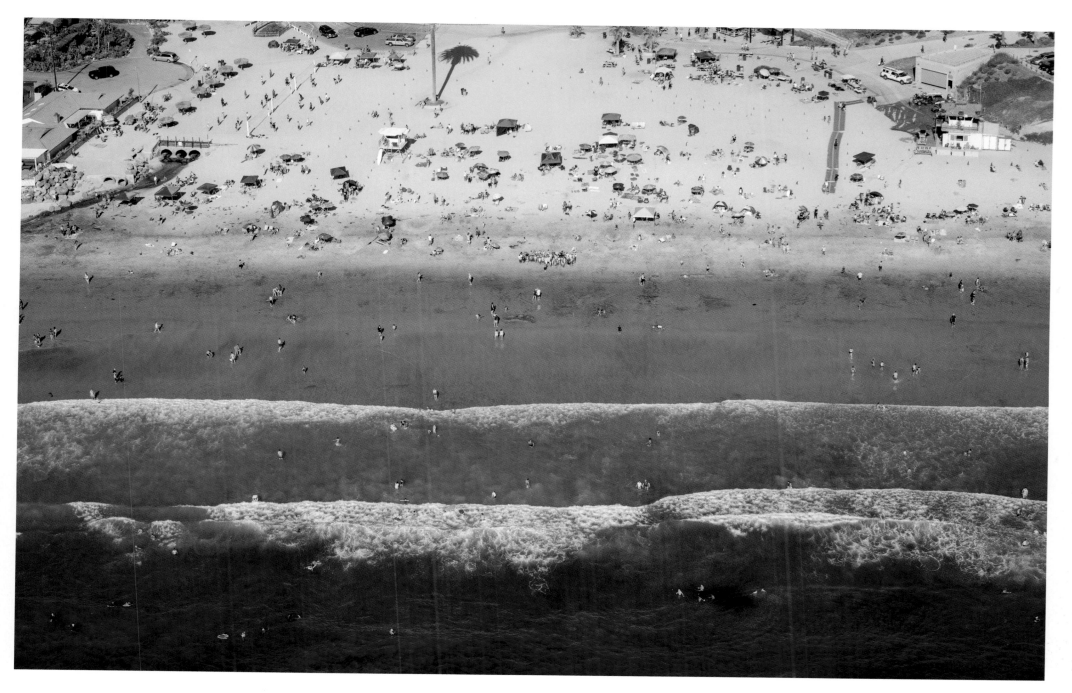

MOONLIGHT BEACH AERIAL, ENCINITAS

Memorial Day is the busiest beach day of the year in San Diego. This image captures the Memorial Day fun in the sun at Moonlight Beach.

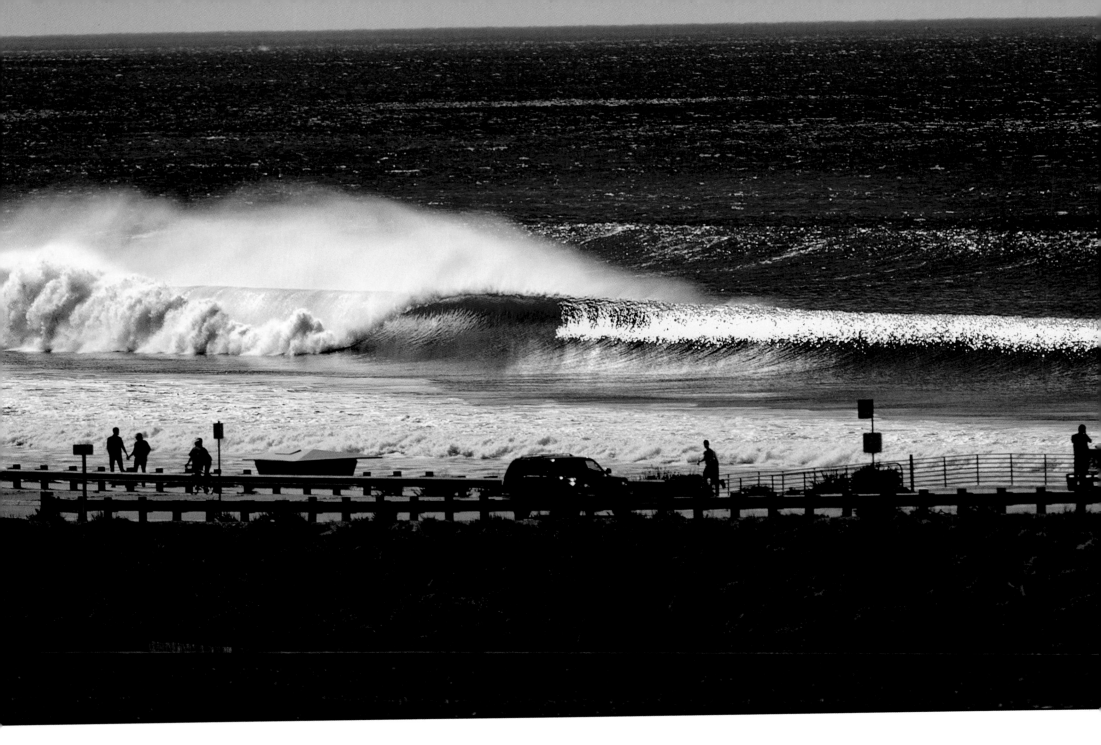

TORREY PINES LINEUP

Perfect off-shore winds create a classic day at the beach. To see Aaron's slideshow about surfing in San Diego, visit AaronChang.com/no-place-like-home.

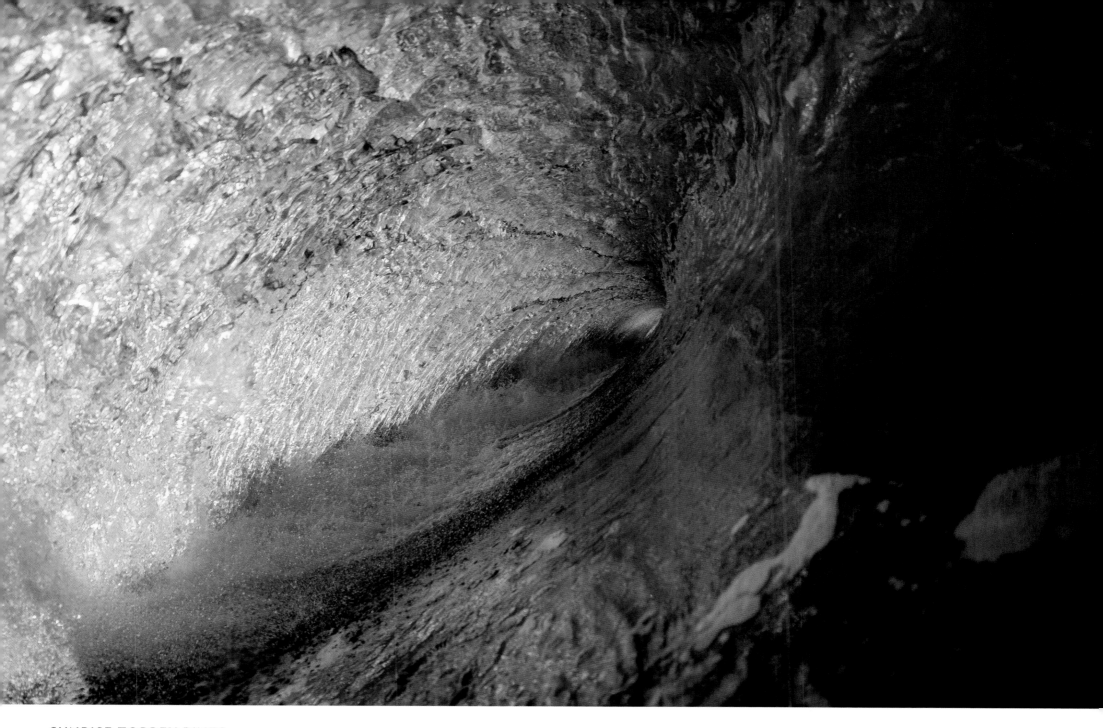

SUNRISE TORREY PINES

The first rays of dawn stream through a perfect wave at Torrey Pines, as Aaron shoots from inside the breaking wave.

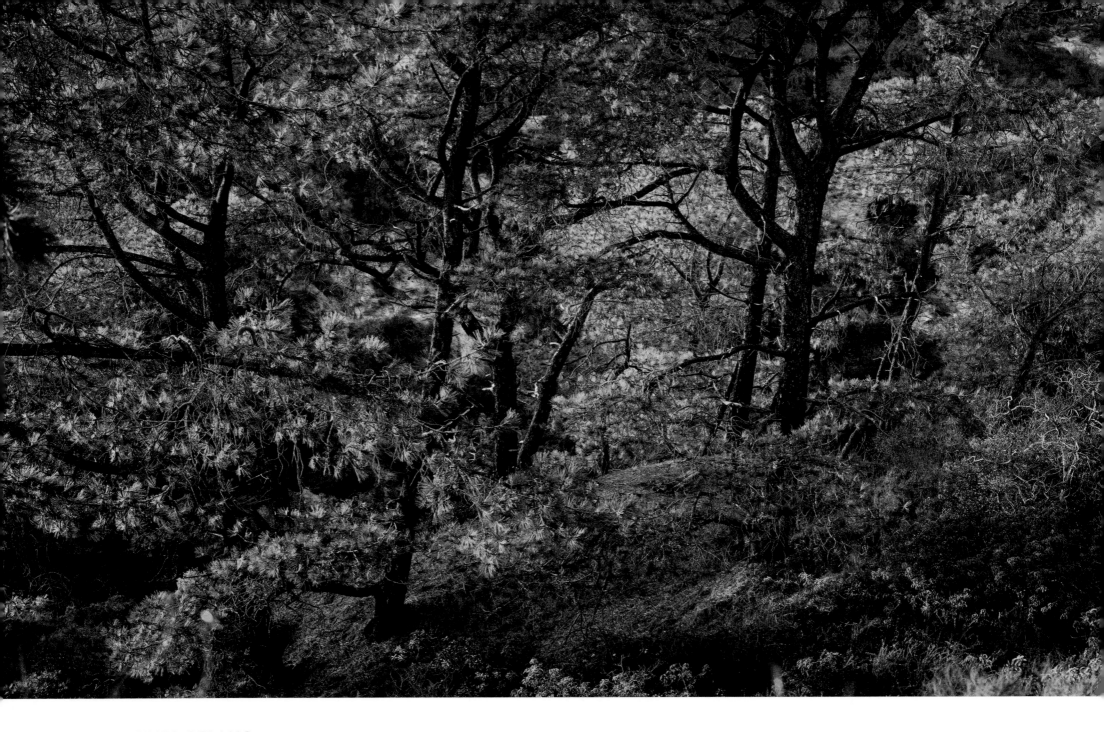

TORREY PINES, DEL MAR
Warm, late afternoon, sunlight beams through the trees creating a fall color palette in this obscure grove of Torrey pines in the north annex of the park.

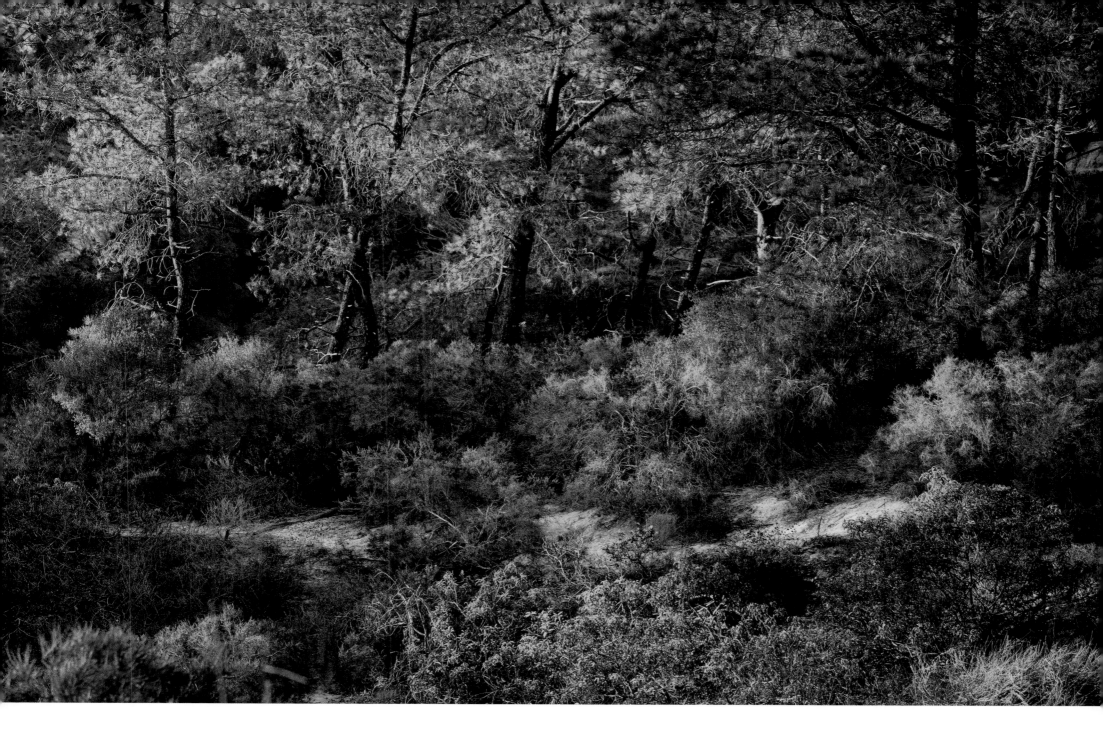

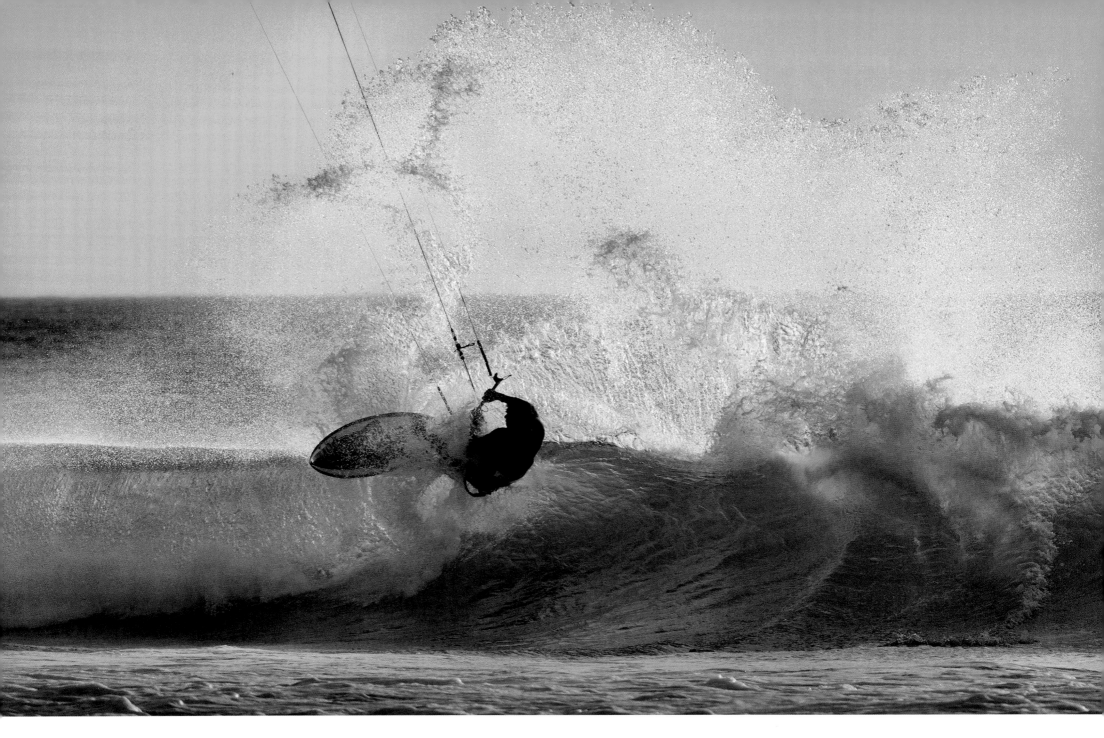

KITE SURFER

Harnessing the power of the wind and waves. To see Aaron's slideshow of San Diego ocean and wave photography, go to: AaronChang.com/san-diego-photography.

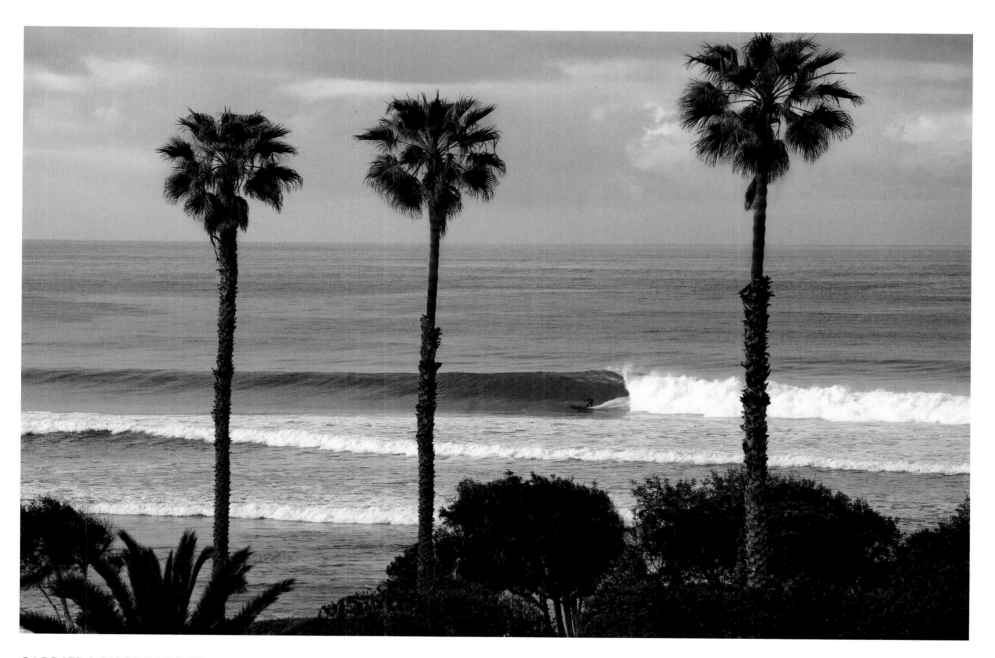

CARDIFF LONGBOARDER

A longboarder is captured carving a wave in Cardiff-by-the-Sea. The pastel palette of the sky is mirrored in the glassy ocean in this California surf classic.

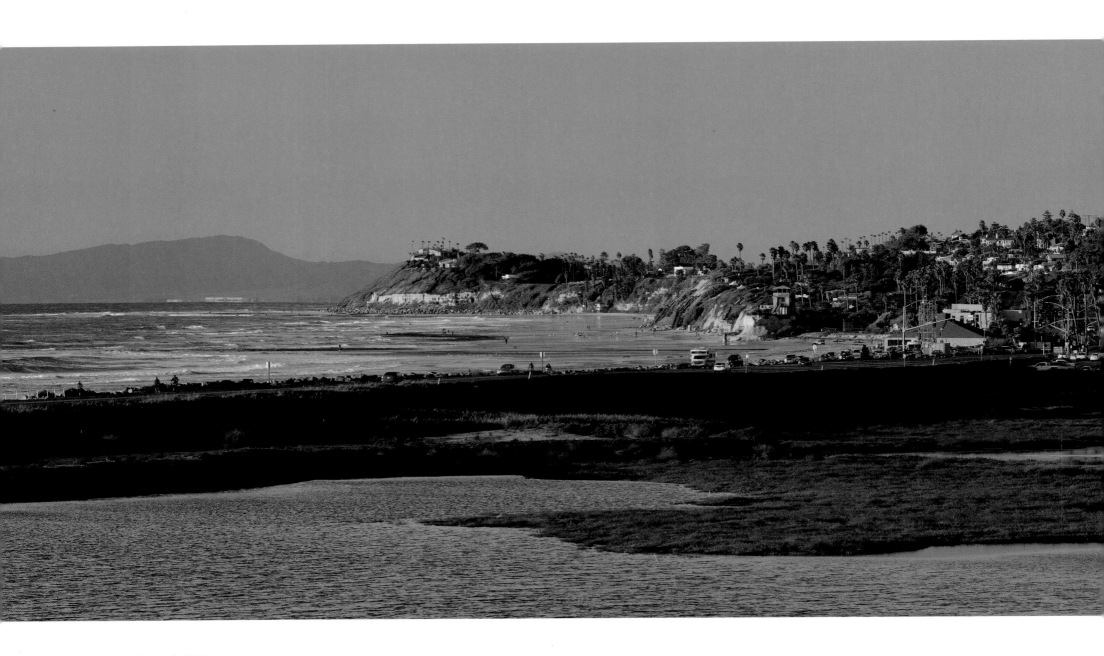

SAN ELIJO LAGOON
One of the most beautiful stretches along the San Diego 101 Highway, as Solana Beach turns into Cardiff-by-the-Sea. The lagoon is on the east with a perfect reef break to the west.

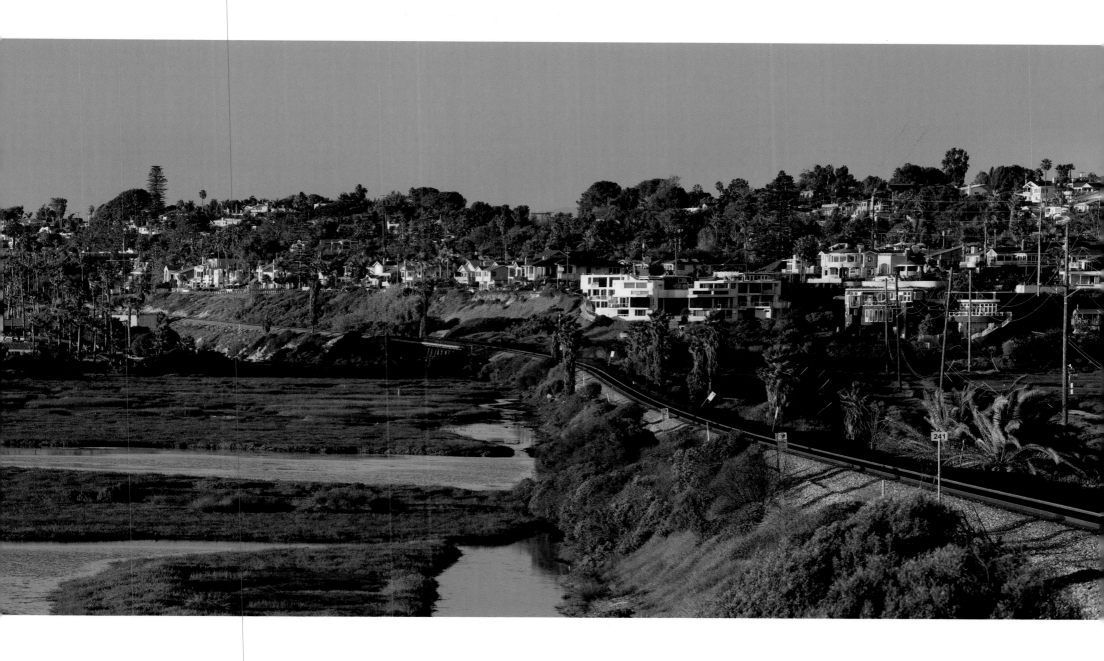

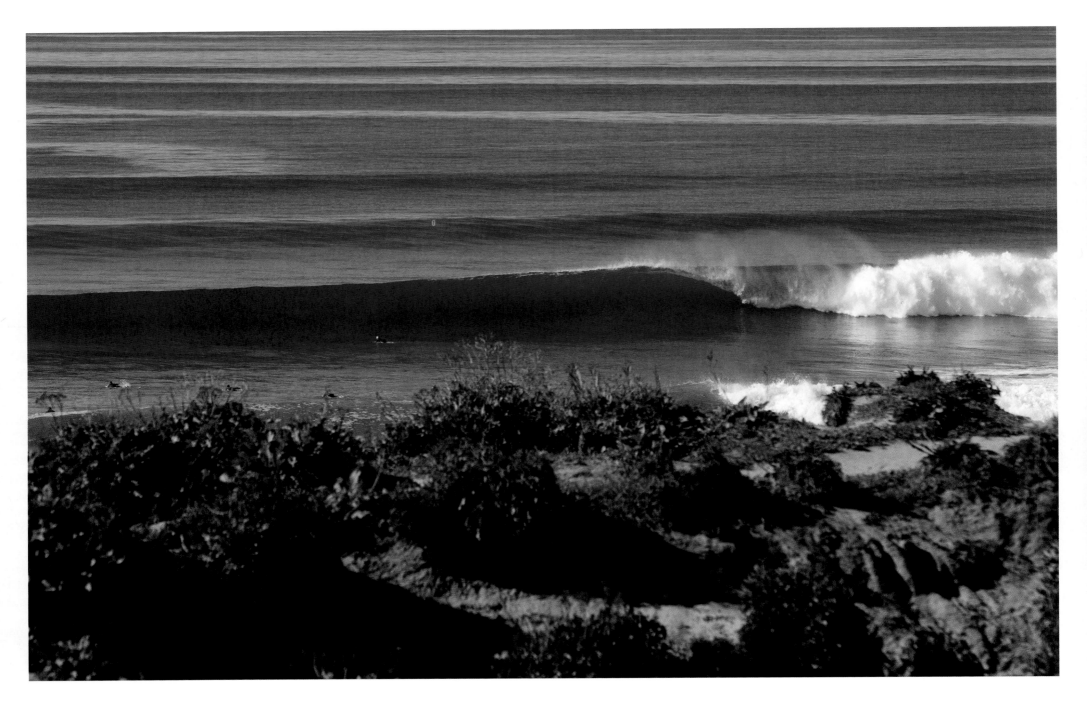

DEL MAR REEF
A local surf spot beneath the sandstone cliffs in Del Mar.

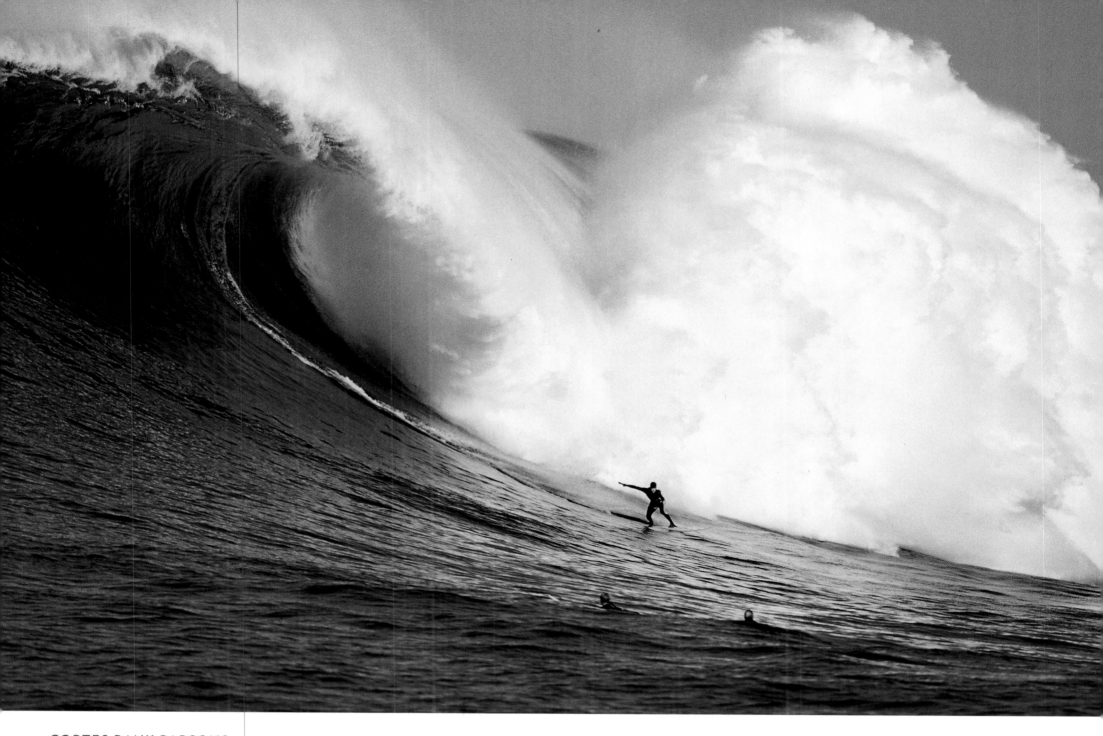

CORTES BANK PARSONS

San Clemente resident, Mike Parsons, rides a 67-foot wave breaking in the open ocean 100 miles due west of San Diego harbor. This wave was awarded "Wave of the Year" in 2001.

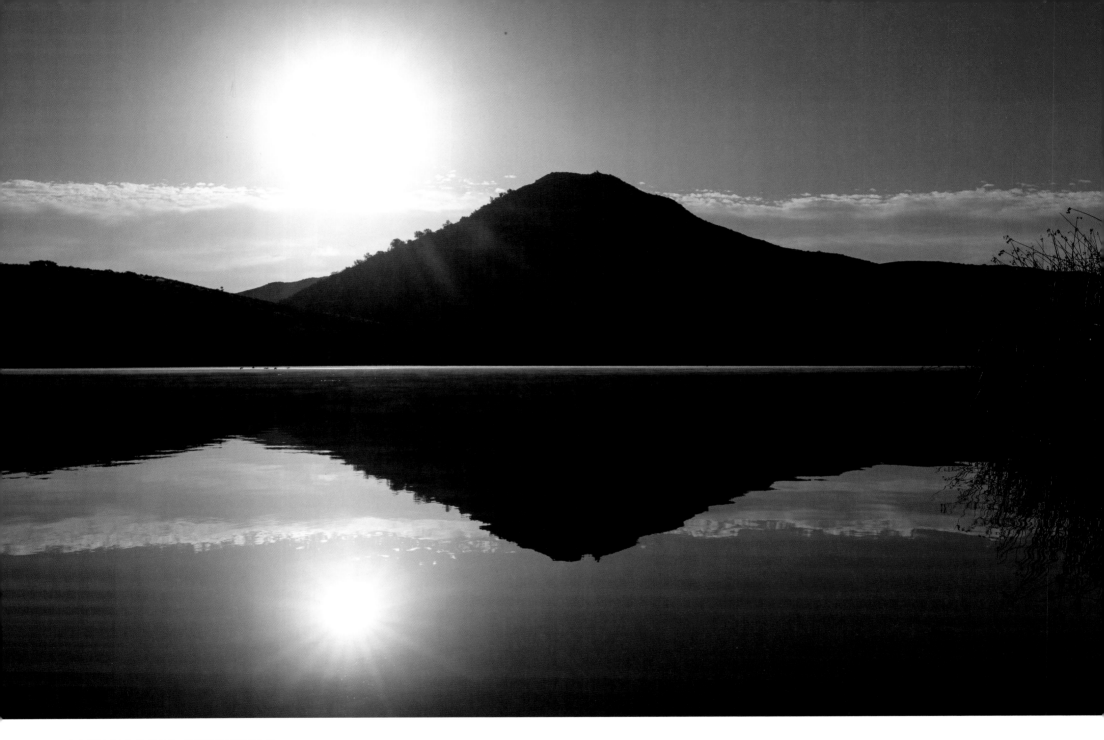

LAKE HODGES, ESCONDIDO

Not a breath of wind creates a perfect sheet of glass on the water's surface of Lake Hodges. To see Aaron's San Diego Inland Collection, commissioned by Sharp Hospital Rancho Bernardo: AaronChang.com/san-diego-inland

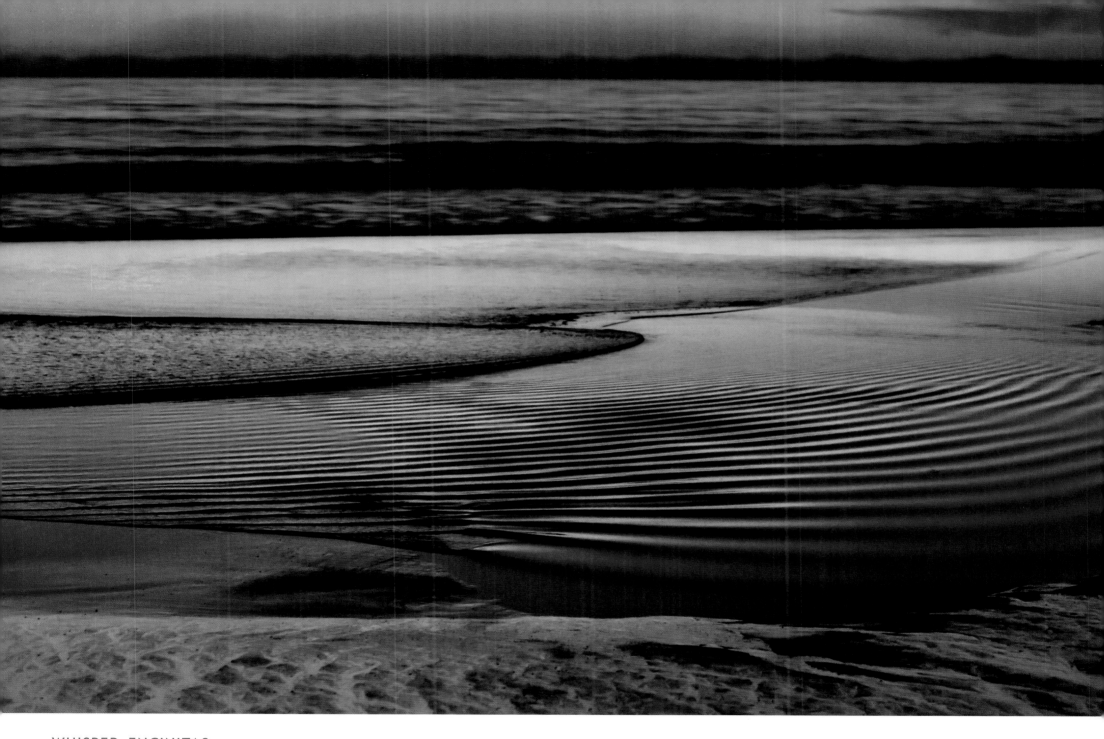

WHISPER, ENCINITAS

In this photographic masterpiece, Aaron captures the delicate, rippled reflection of a seaside sunset as a bank of fog rolls forth on the horizon. Dark contrasts with light in this powerful piece.

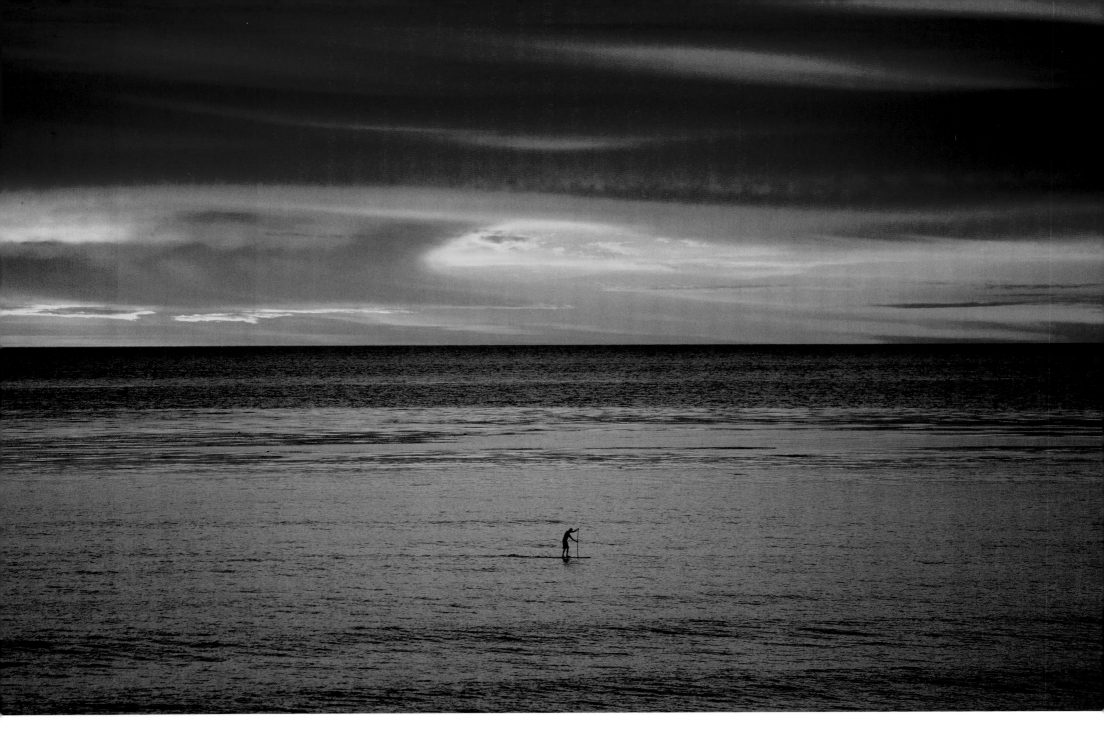

SOLACE

A stand up paddleboarder in Carlsbad glides through the glassy ocean against a fiery sky.

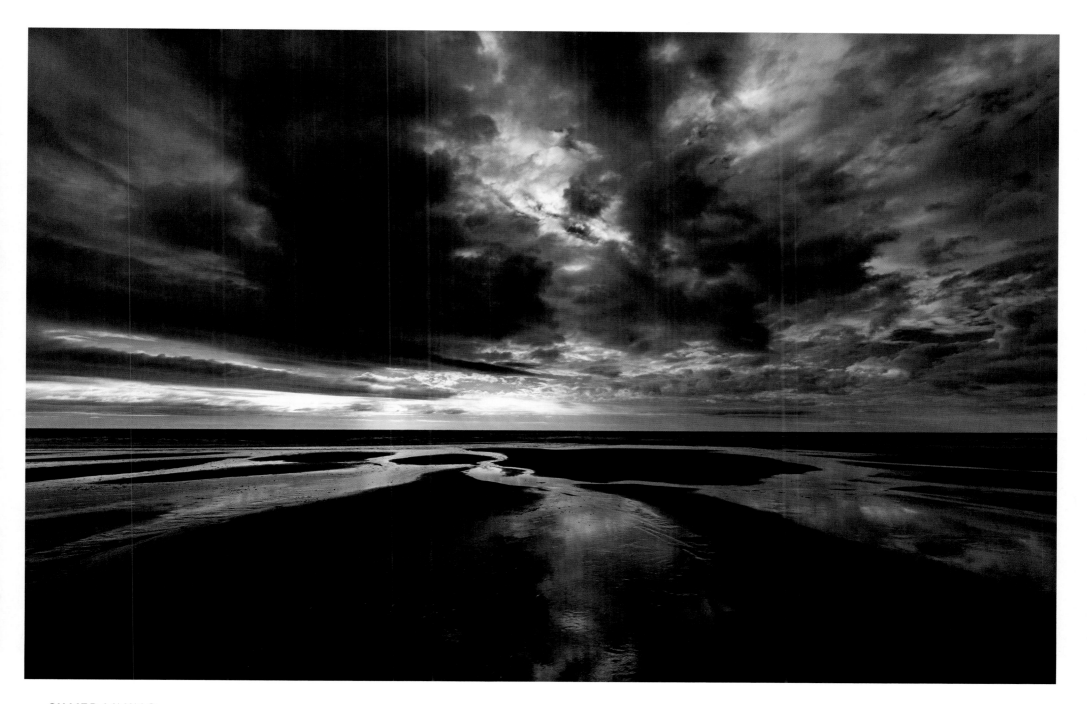

SILVER LINING

Tide pools in the sand, during an extreme low tide, create a reflection of the dramatic clouds of a winter storm at Cardiff Reef.

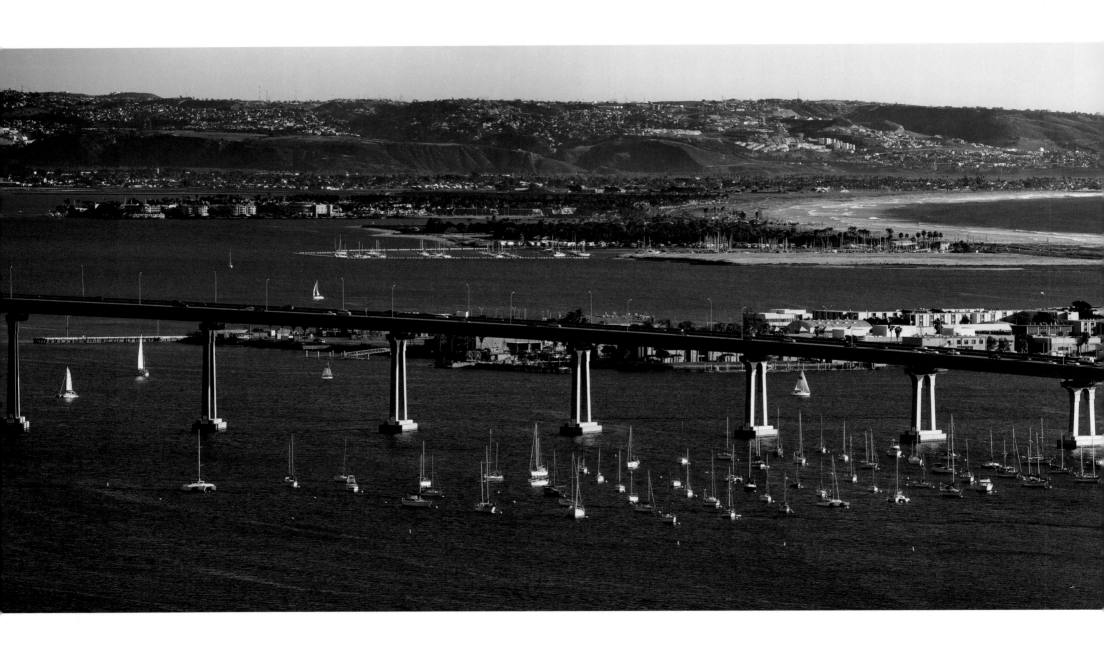

SOUTH BAY SPLENDOR
The Coronado Bridge beckons viewers to its beautiful beaches, down through Imperial Beach and into the hills of Baja California. A stunning view of South San Diego... and beyond.

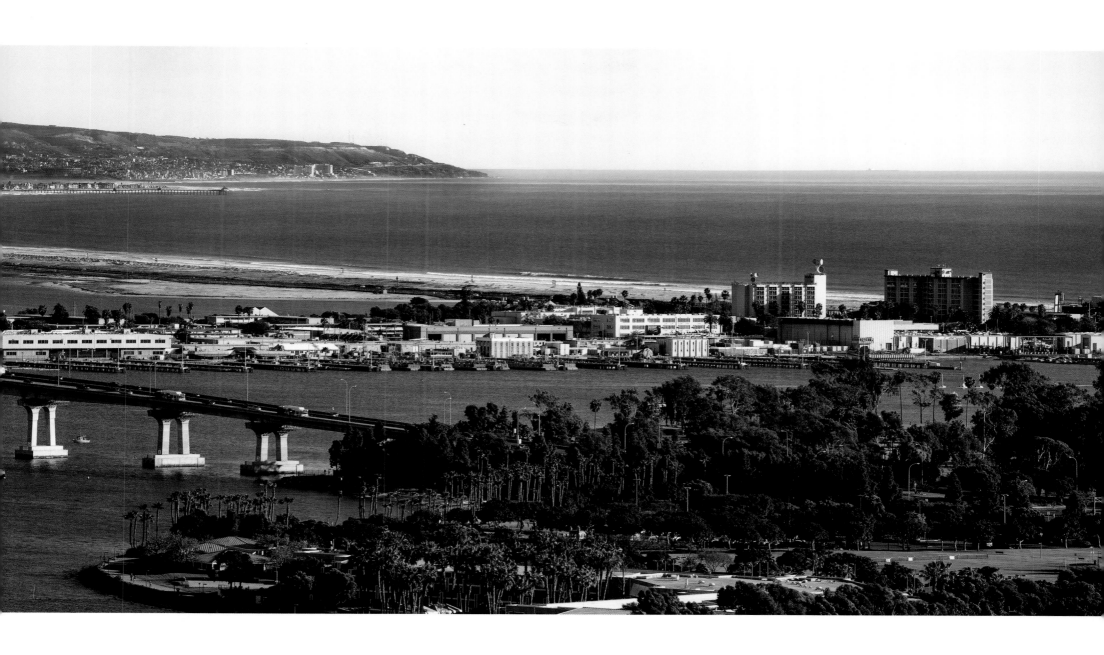

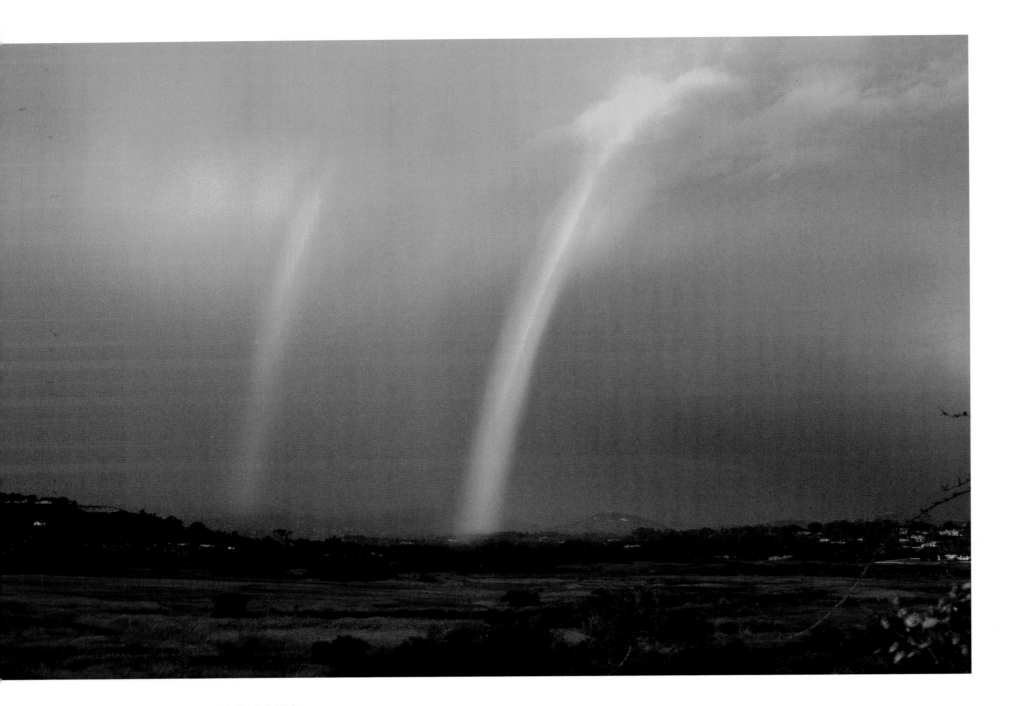

RANCHO SANTA FE RAINBOWS

A rare double rainbow shines over the land of milk and honey. Abundant and rich, the earthy colors in this photo lay down while the bright rainbows pop overhead.

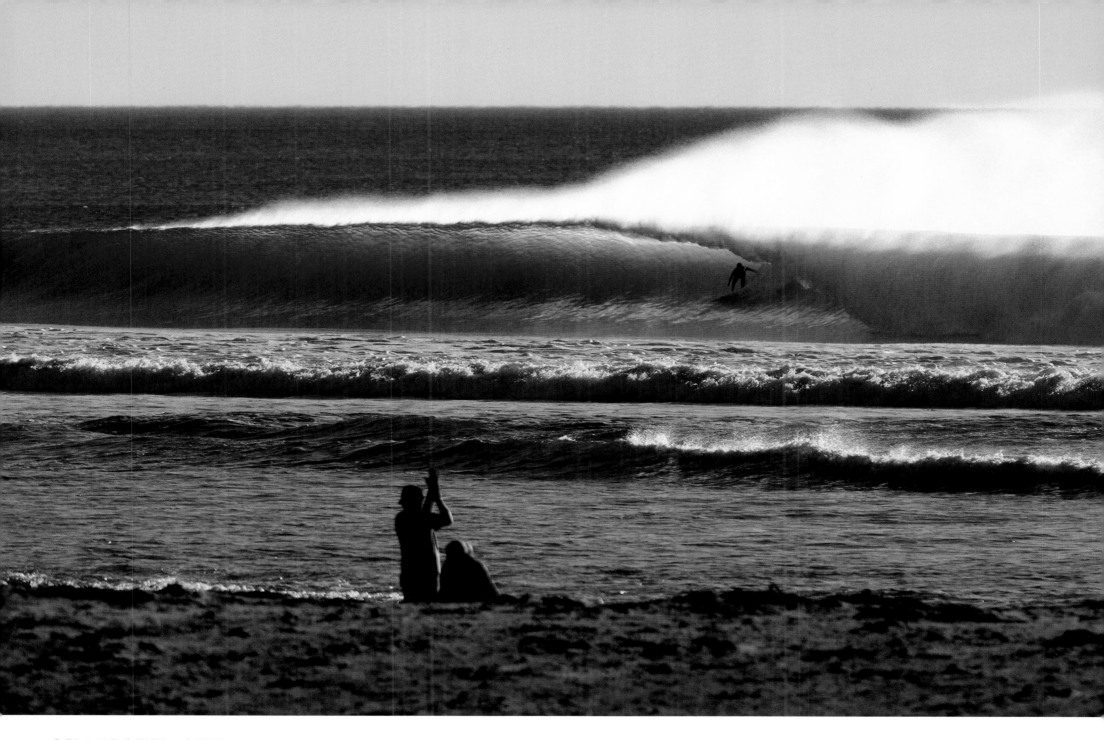

DEL MAR RIVERMOUTH

The joy of riding a perfect wave is always better when you have a witness. This photograph was published on the cover of *Surfing Magazine* and became one of the magazine's best selling issues of all time. To see Aaron's story behind this shot, go to his behind-the-scenes video: AaronChang.com/surfing-magazine.

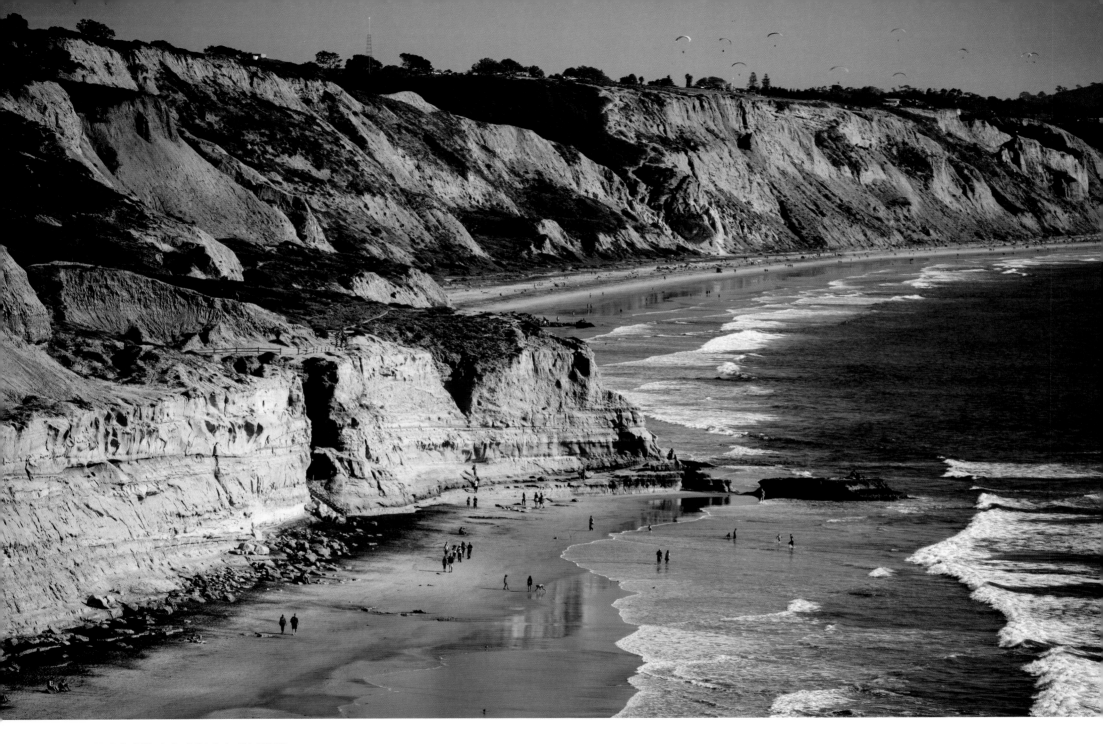

FLAT ROCK, LA JOLLA CLIFFS
A popular hiking destination, Flat Rock sits at the base of the cliffs on the beach below Torrey Pines State Natural Reserve.

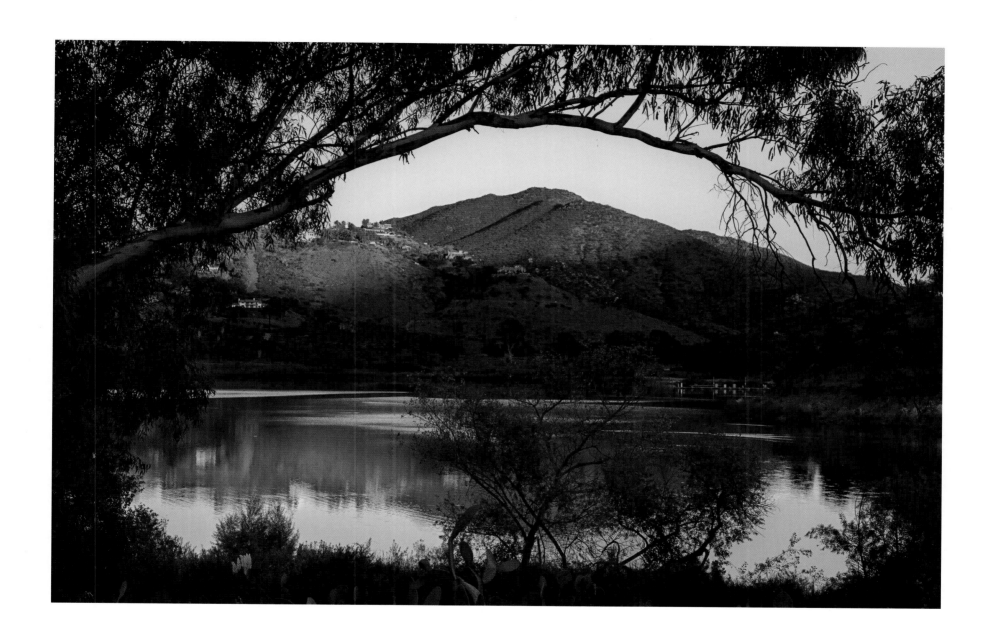

BERNARDO MOUNTAIN, RANCHO BERNARDO

With Lake Hodges in the foreground and framed by a Eucalyptus tree, the last light of the day illuminates the top of Bernardo Mountain. To see Aaron's San Diego Inland Collection, commissioned by Sharp Hospital Rancho Bernardo: AaronChang.com/san-diego-inland

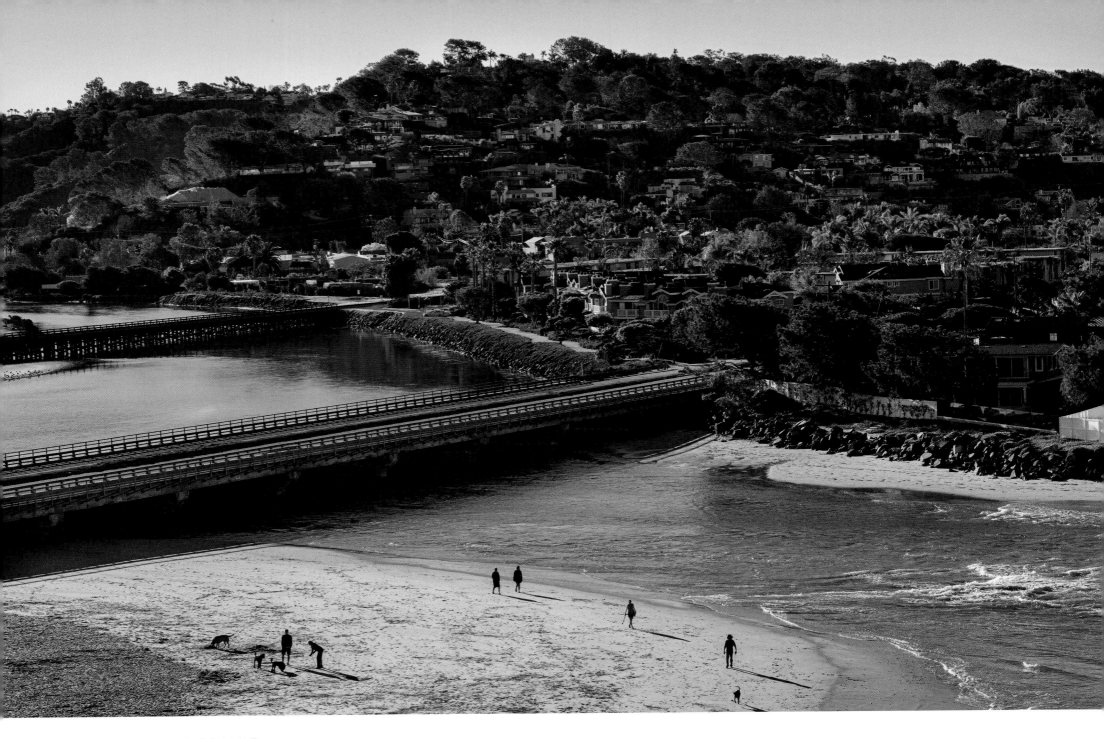

DEL MAR PANORAMIC

This unique panoramic of Del Mar illustrates the relationship San Diego's beach communities have with the water. Appearing as a island, Del Mar is wrapped by the San Dieguito Lagoon on the north and the Los Penasquitos Lagoon on the south.

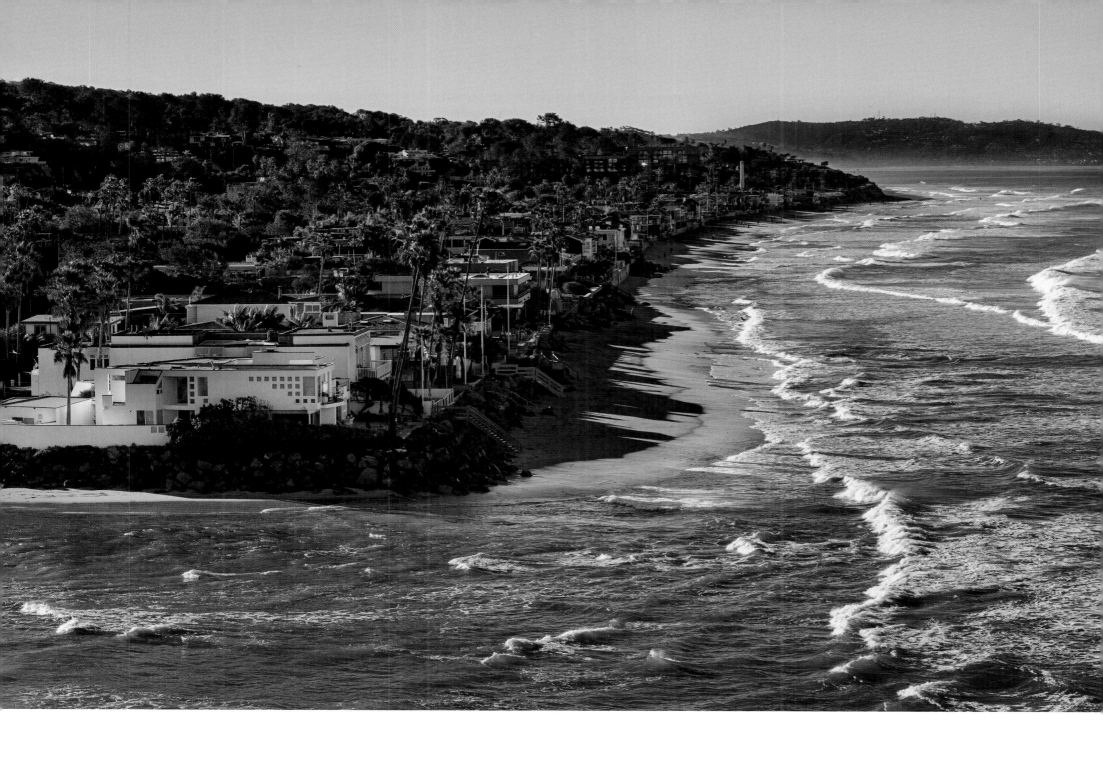

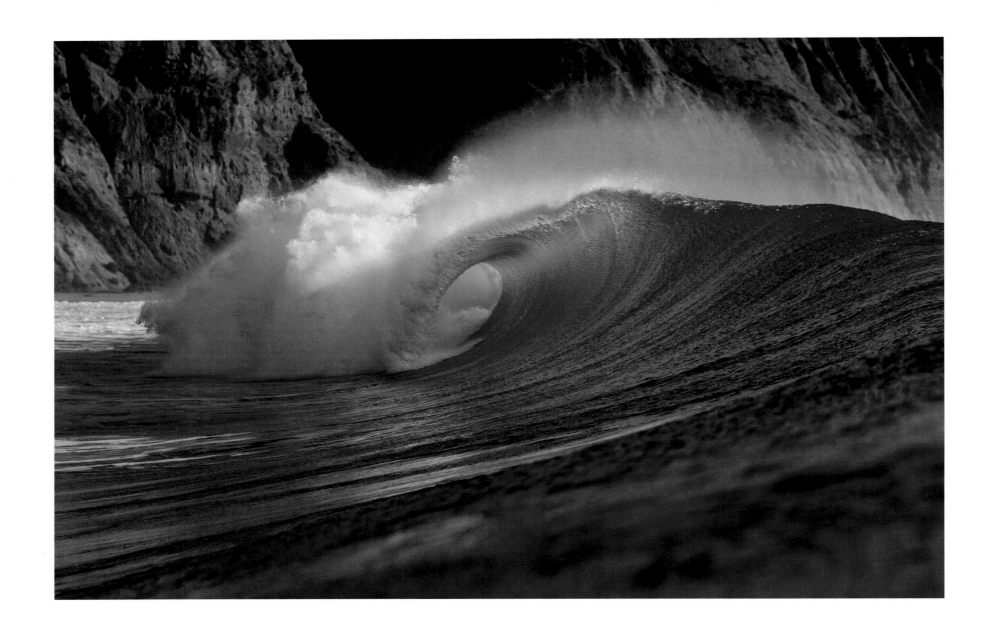

MAJESTIC DAY

Aaron shot this wave from the water at Black's Beach in La Jolla. On an epic day, this spot boasts an exotic beauty that stuns even locals.

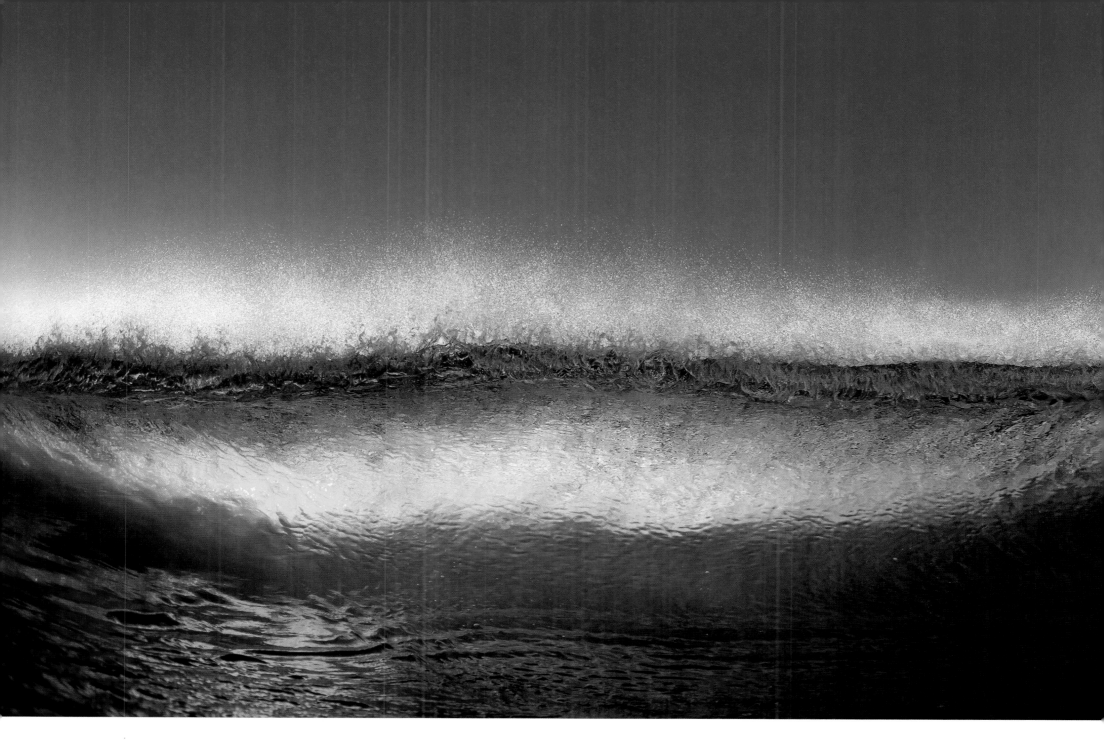

WAVE ABSTRACT
Swimming into the peak with his camera in a water housing, Aaron photographed the lip of a Solana Beach wave launching over him at sunset.

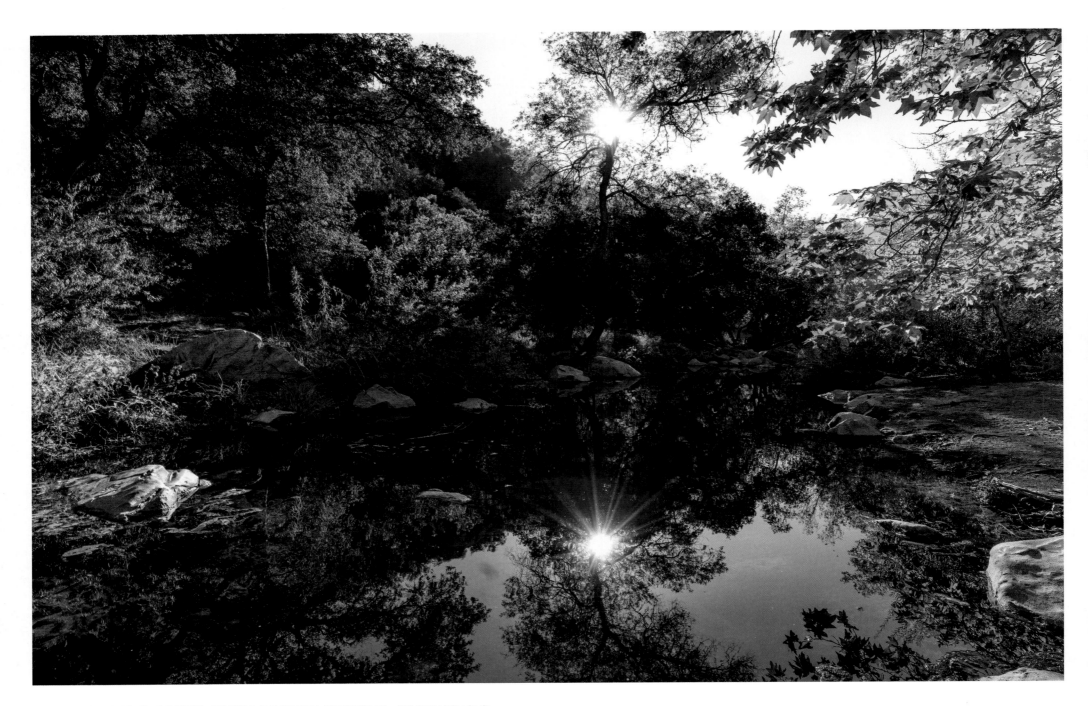

ESCONDIDO CREEK, ELFIN FOREST RESERVE, ESCONDIDO

A hidden gem of North County, the Elfin Forest Reserve is a beautiful place to commune with nature in the middle of suburbia. To see Aaron's San Diego Inland Collection, commissioned by Sharp Hospital Rancho Bernardo: AaronChang.com/san-diego-inland

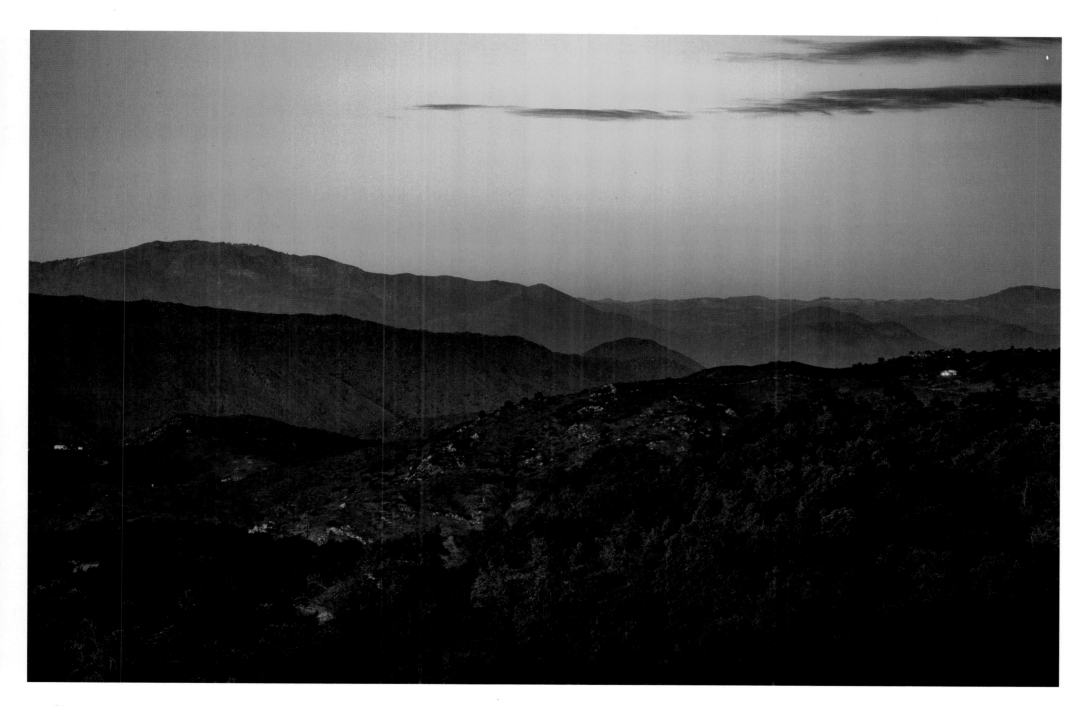

CUYAMACA MOUNTAINS, EAST SAN DIEGO COUNTY

Looking east from on top of Starvation Mountain across the foothills of the Cuyamaca mountains. To see Aaron's San Diego Inland Collection, commissioned by Sharp Hospital Rancho Bernardo: AaronChang.com/san-diego-inland

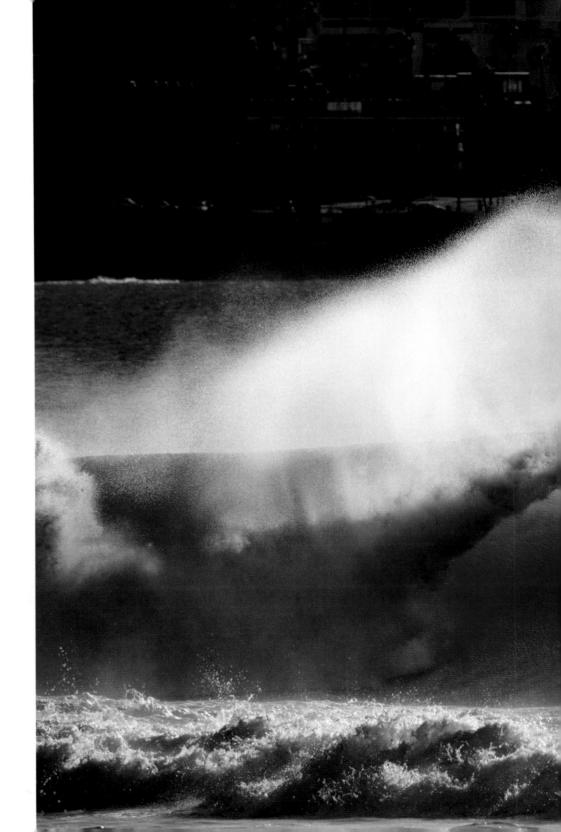

LA JOLLA SESSION

A surfer paddles out to the line-up on a crystal clear day with solid surf. The plume of the wave silhouettes against the La Jolla coastline.

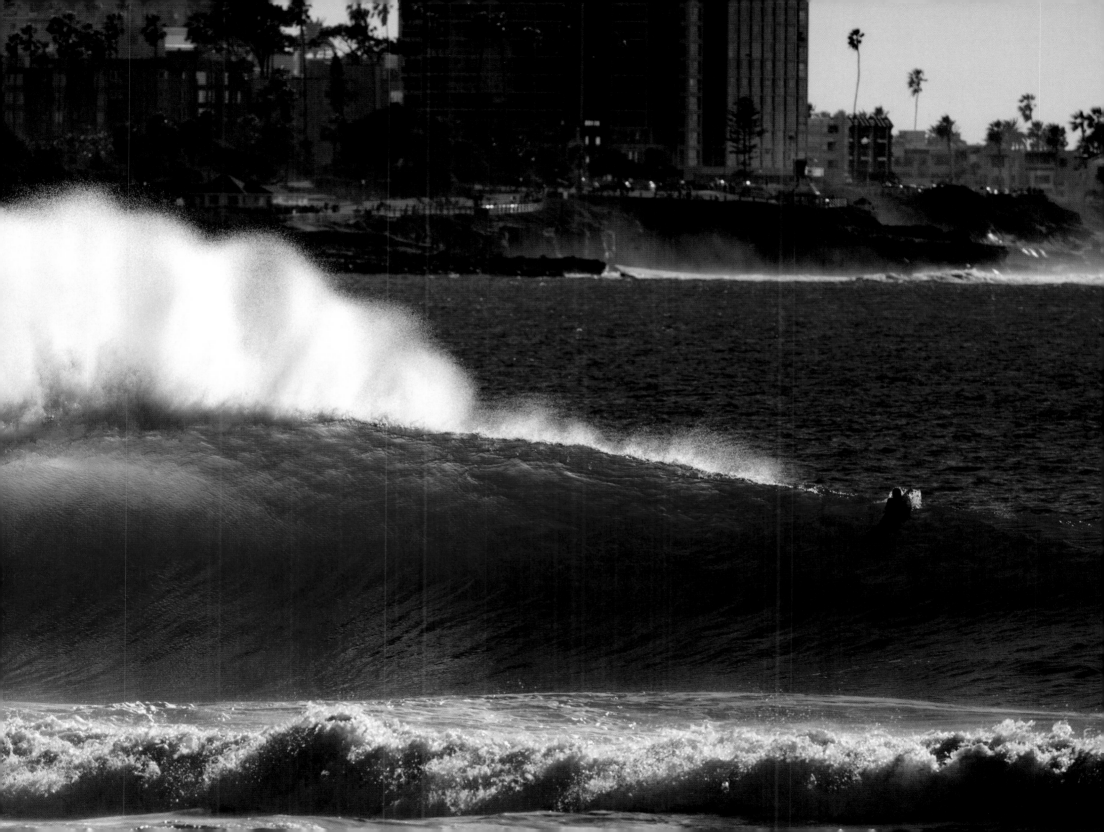

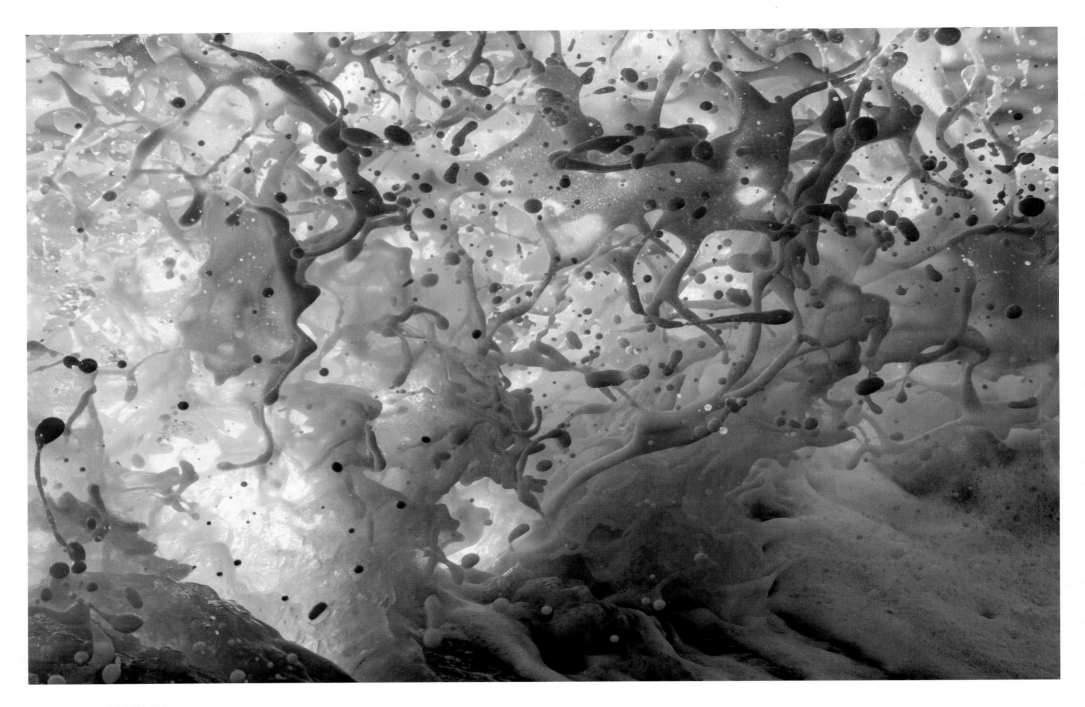

WATER MATRIX

This action photo freezes a moment in time where the splashing water of a small shorebreak wave becomes something entirely otherworldly. Abstract yet real, this image pays homage to Jackson Pollock. Feel the pure summer summer-joy of a wave breaking around you. This is one of our fastest selling gallery images: AaronChang.com/water-matrix_blog

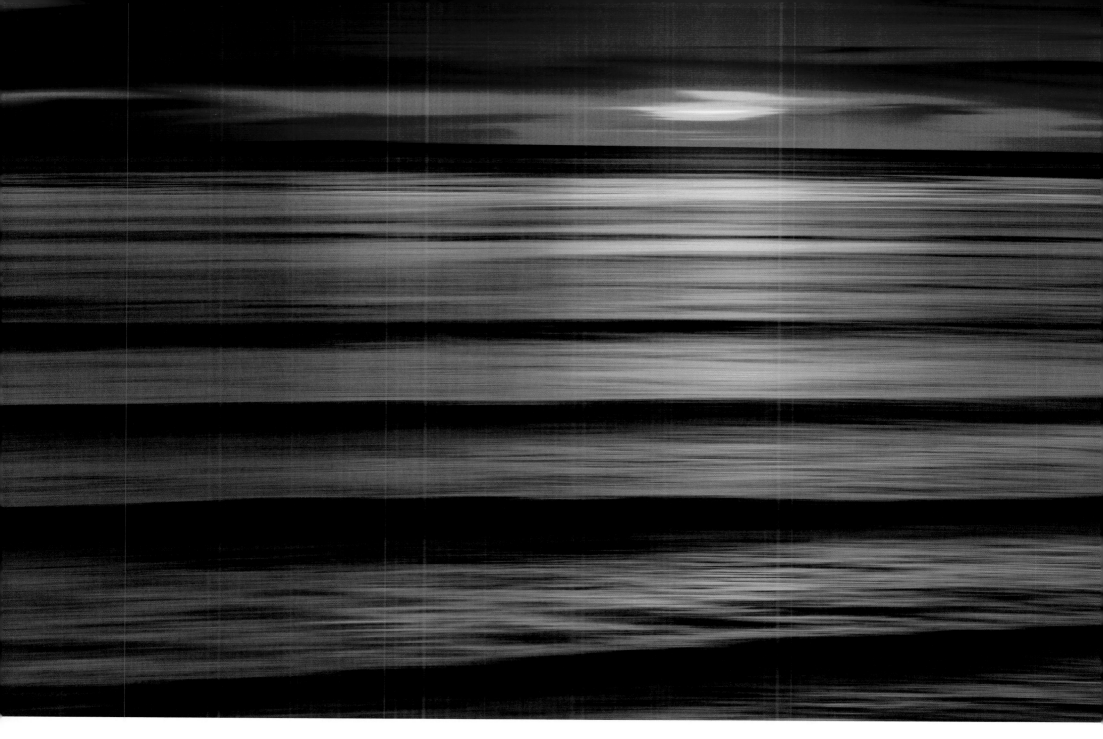

BLACK PEARLS

During a west winter swell, Aaron captured the setting sun with a set of four waves moving toward the shore in Carlsbad, framed against an explosive Californian sunset.
To see Aaron's story behind this best-selling shot of his career, visit AaronChang.com/black-pearls.

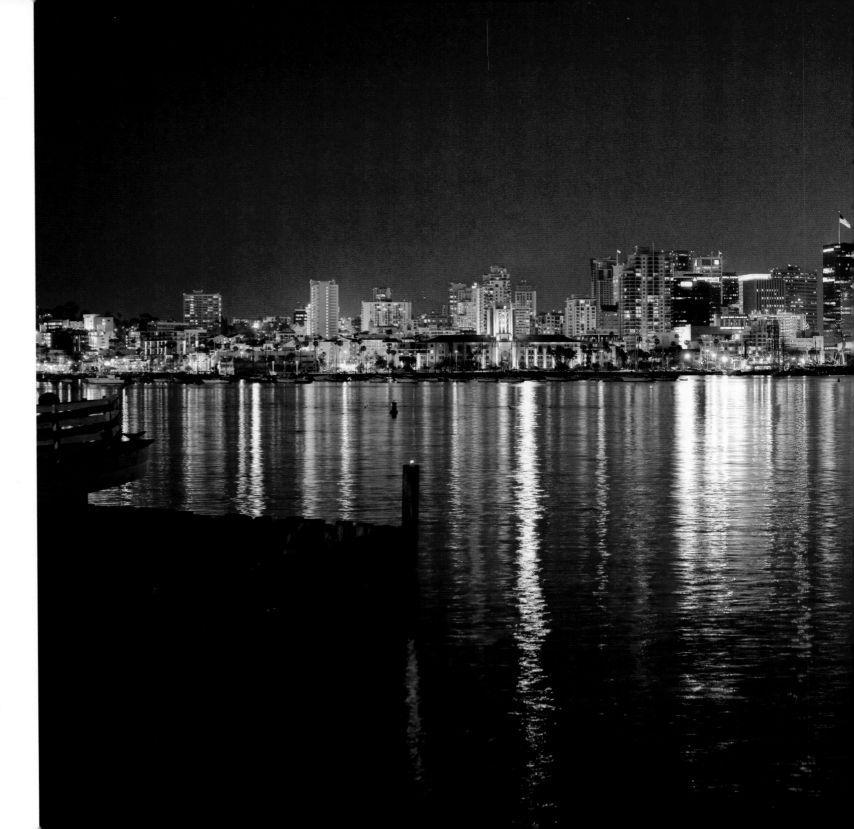

SAN DIEGO NIGHT SKYLINE

A plum sky fades to black as the city of San Diego sparkles like a gem reflected on the water.

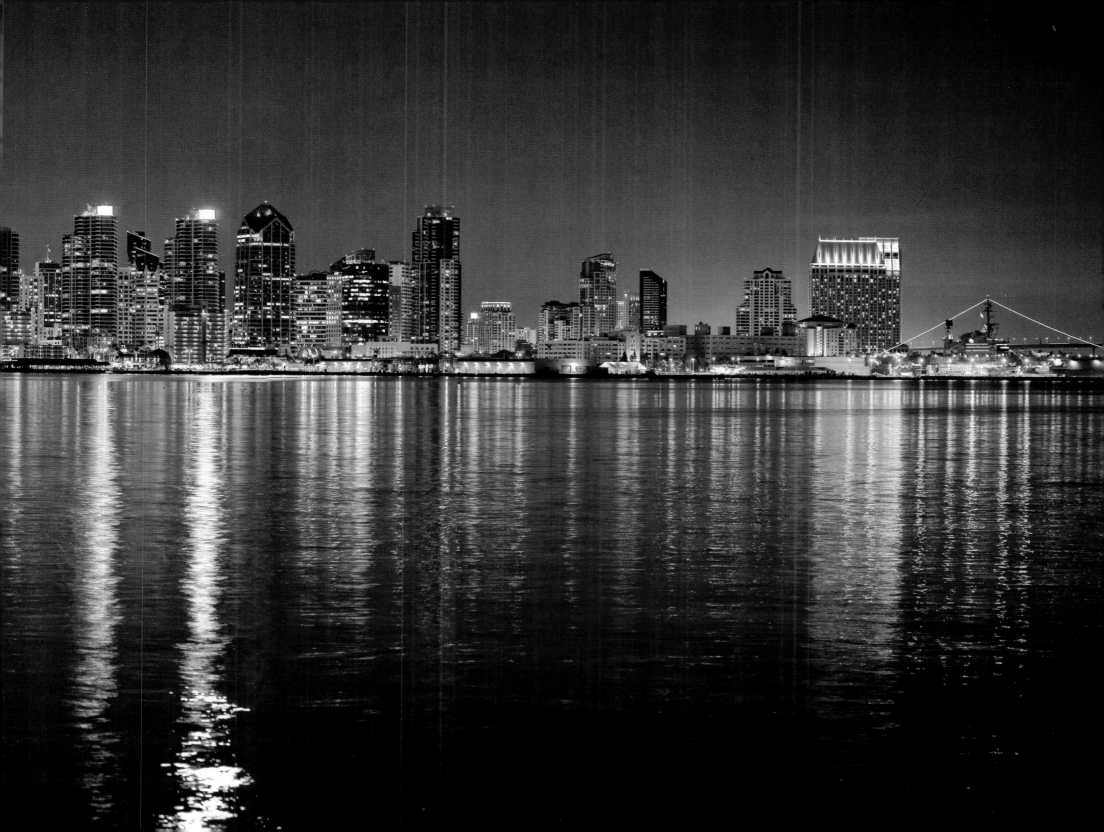

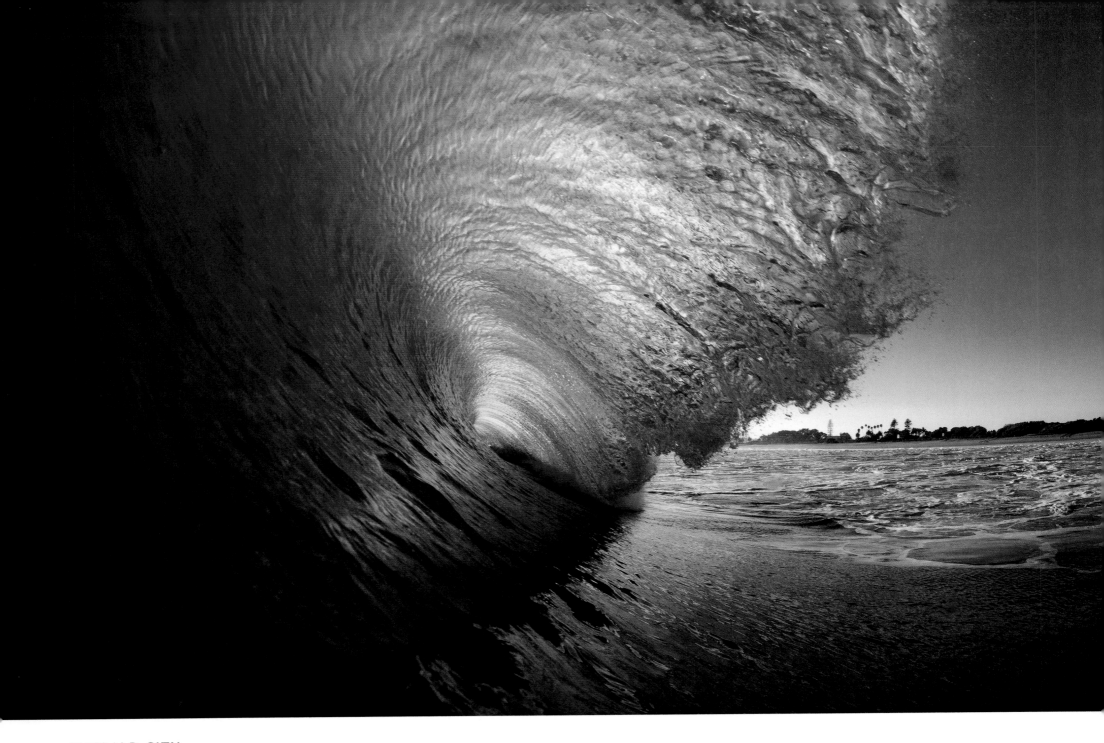

EMERALD CITY

A perfect wave is captured as it races to shore during a powerful summer swell. This image was shot on the island of Coronado.

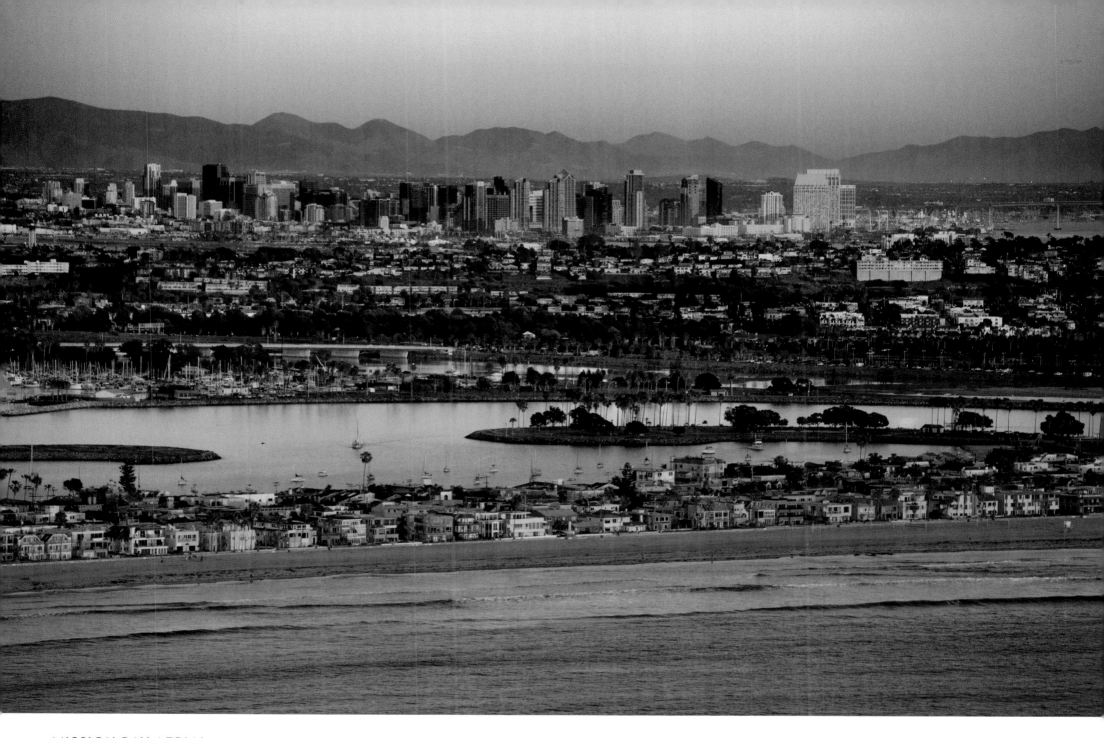

MISSION BAY AERIAL

San Diego is truly a water city. This shot reveals the interconnectivity between not only the ocean and the city, but also San Diego Bay and Mission Bay.

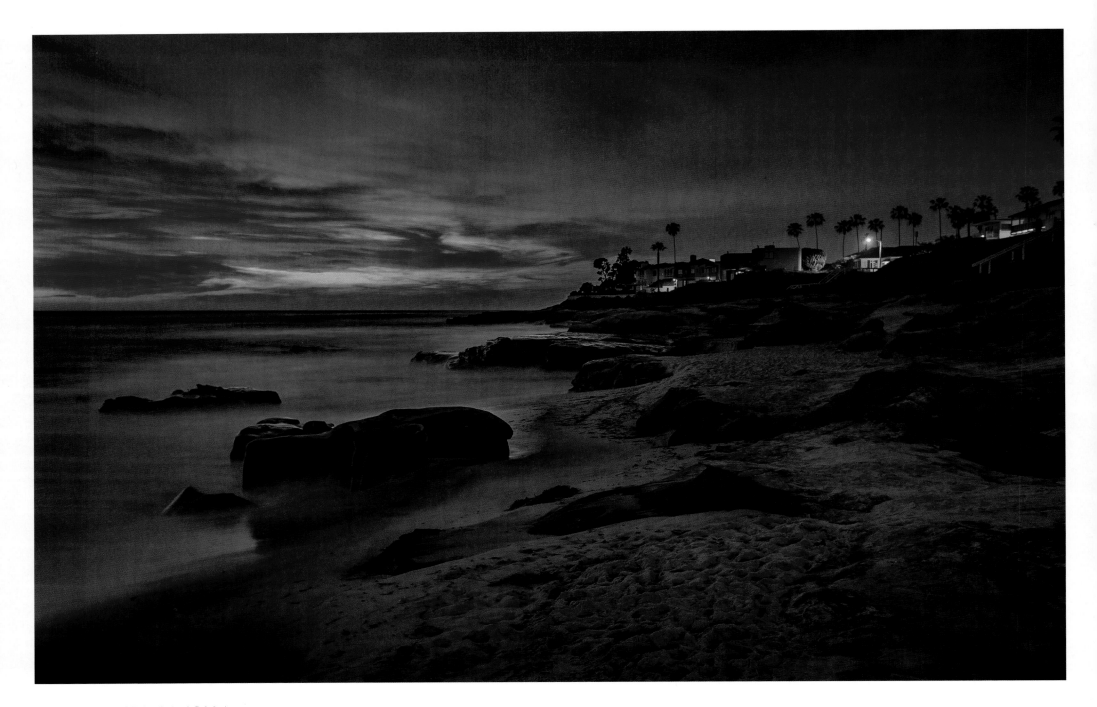

WINDANSEA, LA JOLLA

The afterglow is the most colorful part of a sunset. Interestingly, when the color is at its peak, most people who have watched the sunset are long gone when this moment happens.

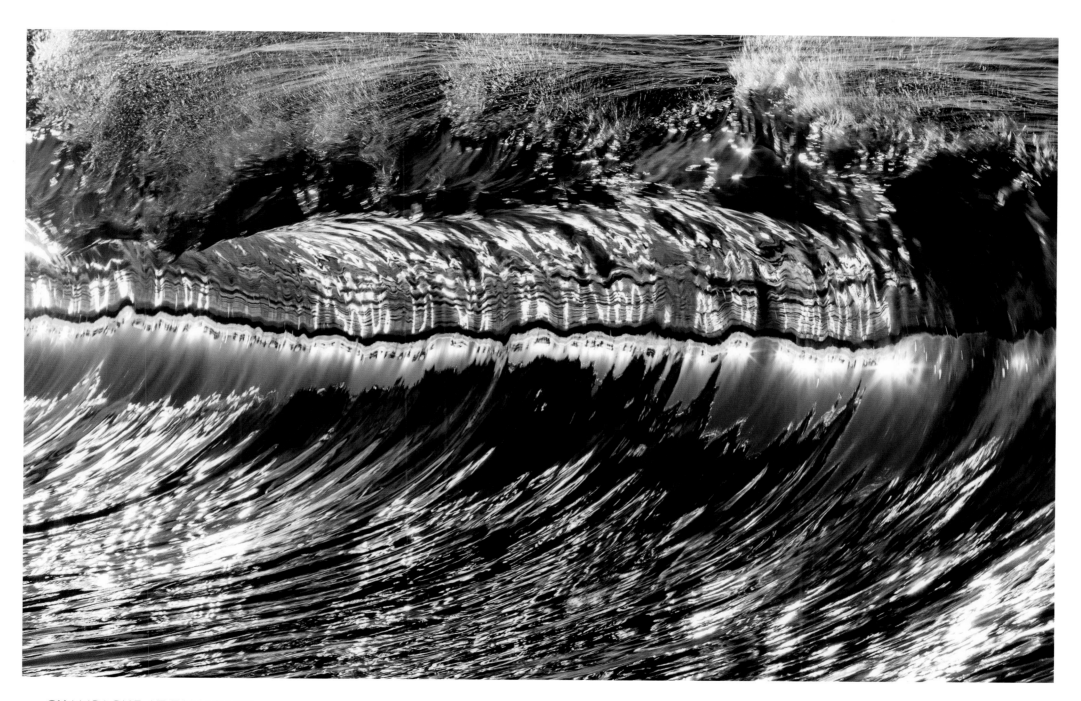

CHAMPAGNE AT TAMARACK

The beauty of the rising sun is reflected on the face of a glassy wave breaking in Carlsbad. This festive image is a stunning display of nature's golden light. To see Aaron's video behind this shot, go to: AaronChang.com/champagne.

On July 10, 2010, the Aaron Chang Ocean Art Gallery opened its flagship location at 415 South Cedros Avenue, in the heart of the Solana Beach Design District. Founded by award-winning, internationally acclaimed local artist, Aaron Chang, the gallery has drawn locals and visitors from around the world.

"I love Solana Beach," states Chang. "We opened our first gallery at a very precarious economic time, and we depended on our community to get us up and running. The love and support we have received from the North County residents over the years far exceeds anything I could have hoped for. When I'm not shooting or traveling, I truly love to be here!"

The Solana Beach gallery features Aaron's large format photographic prints with surf and ocean themes alongside several striking surfboard sculptures. All of the work is available in custom sizes to transform the character of any commercial or residential space.

The gallery seeks to be active in the community and often hosts events for charities, schools and group functions. Are you hosting a mixer? A fundraiser? Please call a gallery associate for details: (858) 345-1880.

To see photos of the gallery and go on a virtual tour, go to: AaronChang.com/ Solana-beach-gallery.

In December 2013, the Aaron Chang Ocean Art Gallery opened its second location at 789 West Harbor Drive at The Headquarters, a newly completed project in the Seaport District of San Diego. This remodeled, luxury waterfront plaza was once the San Diego Police Department's headquarters and jail.

Upscale and modern throughout, The Headquarters preserved some of the historical elements of the property, resulting in a unique experience. Adjacent to the Manchester Grand Hyatt, the Aaron Chang Ocean Art Gallery complements its modern elegance with a view of the San Diego Bay. Flanked by popular restaurants, the gallery at The Headquarters welcomes an eclectic mix of local residents, international tourists and business travellers.

"The Headquarters is a special place," says gallery owner and artist,

Aaron Chang. "It's gratifying to be able to present images of the power and beauty of the ocean to people from all over the globe...the draw of the sea evokes such powerful human emotions."

The Headquarters gallery features Aaron's large format photographic prints with surf and ocean themes alongside several striking surfboard sculptures. All of the work is available in custom sizes to transform the character of any commercial or residential space. The gallery seeks to be active in the community and is available for group functions and events. Are you hosting a mixer? A fundraiser? Please call a gallery associate for details: (619) 567-8088.

To see photos of the gallery and go on a virtual tour, go to: AaronChang.com/san-diego-gallery.

AARONCHANG.COM

Like all fine art, Aaron's work is best viewed in person and can be seen at Aaron Chang Ocean Art Galleries.

789 West Harbor Drive
Suite 156
San Diego, CA 92101
(619) 567-8088

415 South Cedros Avenue
Suite 110
Solana Beach, CA 92075
(858) 345-1880

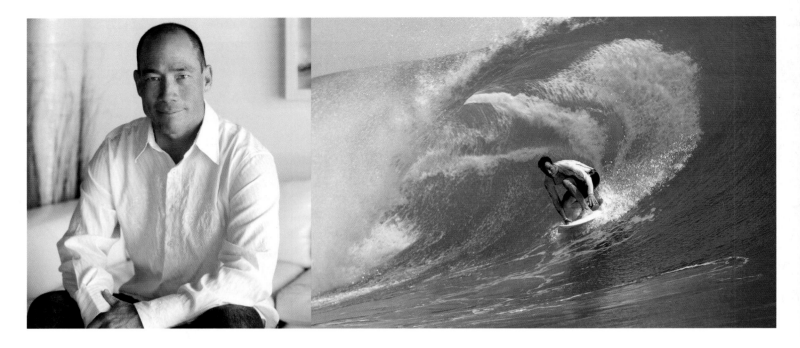

As a force in visually defining the sport of surfing, Aaron has pursued his photography to the far ends of the earth. For 25 years, as a senior photographer for *Surfing Magazine*, Aaron was at the core of the surfing world, discovering new talent and surf spots around the globe. Having traveled to more than 40 countries in search of the perfect adventure, Aaron's work has graced the covers of more than 100 magazines. In addition, Aaron has worked for some of the most prestigious commercial accounts, shaping their brand through his world-class gift for photography.

The Aaron Chang Ocean Art Gallery was voted "Best Gallery" in 2011 and 2012 and Aaron "Best Artist" in 2013, 2014 and 2015 by *Ranch & Coast* magazine readers. Aaron was also named the "Ambassador for the Arts" in 2014 and 2015 by the San Diego Tourism Authority. In 2016, Aaron was voted both Best Art and Gallery of the year, a very unique and prestigious honor.

Aaron recently opened his second gallery at The Headquarters, a luxury waterfront plaza in the Seaport District of San Diego, specializing in large-scale fine art

prints of Aaron's best work. Aaron's art is setting new standards in photography on traditional and creative-contemporary mediums. Some of Aaron's most iconic art includes a 10-foot image of the view inside a wave, shot from the water; and his ever-popular surf board sculpture, which is a three-dimensional image wrapped onto a surfboard, popping off of a background print.

The Aaron Chang Gallery has partnered with charities over the years to give back to local and international communities. "This is an amazing opportunity to help others in need," says the photographer and gallery owner.

An active member of his community, both personally and professionally, Aaron serves on several boards and contributes to many nonprofits. He is a loving husband and father of two boys, as well as an avid surfer, and currently resides in North County San Diego.

For narrated stories behind these shots and to see more of Aaron's work, go to www.AaronChang.com. Find him on Facebook @AaronChangGallery or on Instagram and Twitter @AaronChang.